Cubism in Architecture and the Applied Arts

To
Rudolf and Heda
and
Olga and Daniel

Cubism in Architecture and the Applied Arts

Bohemia and France 1910–1914

Ivan Margolius

David & Charles

Newton Abbot London North Pomfret (Vt)

Margolius, Ivan
 Cubism in architecture and the applied
arts.
 1. Architecture, Modern—20th century
 2. Cubism
 I. Title
 724.9 NA 682.C/

ISBN 0-7153-7673-X

Set in 10 on 11 Gill Sans
by ABM Typographics Ltd, Hull
and printed in Great Britain
by Redwood Press Ltd, Trowbridge
for David & Charles (Publishers) Limited
Brunel House Newton Abbot Devon

Published in the United States of America
by David & Charles Inc
North Pomfret Vermont 05053 USA

Contents

Introduction

Before World War I an original Cubist trend in architecture had appeared in that part of the Austro-Hungarian Empire now called Czechoslovakia and similarly, but on a much smaller scale in France. It is interesting that this phenomenon appeared as a reaction to other visual arts in such a strong and isolated way without picking up support or laying roots in any other parts of the world.

The architects involved in the development of this trend were directly influenced by the emergence of the Cubist paintings several years before. They tried actively to interpret the emotions and composition of the Cubist works of art in a three-dimensional architectural framework. Consequently the houses they planned with the applied vision and skill of painters and sculptors were almost abstract and hardly habitable, with their space contoured by oblique and warped surfaces, and distorted by pyramidal and prismatic projections. Since the buildings were designed with little regard for practical use or structural laws, it follows that some of the projects remained unrealized because of the practical difficulties of constructing them. Because of its disregard for functional and economic requirements, this trend could show itself more easily in the fields of applied arts, in furniture and interior design.

Cubist architecture came as a reaction against the positivist materialism of the nineteenth century, and the functionalist traditions of the teachings of G. Semper and O. Wagner, which were defined by their belief in a synthesis of function, construction and poetry. The Cubists rejected the rationalism and utilitarianism that was based on Renaissance theories and tended rather towards the late Gothic and late Baroque compositions.

The oblique, conical, cut, dynamic forms of Cubist architecture are related to the Art Nouveau style but the relationship with the Baroque forms is closer. The heavy almost mystical configurations of single-colour façades, railings, recesses and folds casting shadows over the surfaces present a very late-seventeenth-century feeling of exuberant decoration, spatially complex composition and expansive moving form.

The new trend showed that 'the surface [of forms] is changed, moved, as if it is in its folds and waves a mixture of matter existing inside the space, which is external to it'.[1] The Cubists tried through their efforts to formulate a concept of modernity that would be true to the spirit of the time. In addition they were influenced by Cubist, Fauvist and Post-Impressionist paintings, and also by the philosophical and aesthetic ideas of T. Lipps and W. Worringer.

The importance of this short-lived style should not be neglected for its originality, theoretical background and perfect execution anticipating what was to come in the development of technology, industry and modern form. The architects involved should be given credit for initiating a genuine architectural trend immediately and directly stemming from an original style of painting. It was a

movement in which all the current expressions of visual arts came to be reflected in examples of realized architectural works. It is interesting that Cubist paintings and sculptures affected spheres of art—architecture, furniture design and applied art—which, in their end product, are basically non-representational.

Sources of Modern
Design Attitudes

The coming profound changes in architectural creativity at the beginning of the twentieth century were conceived from the general and rapid progress of human endeavour. Apart from the changes and progress in the spheres of philosophy, arts and ideas in further development of society, the new scientific and technological innovations and inventions had great effect on the advancement of aesthetic ideas. The machine revolution changed the importance of human skill on which the old world was established. In the working processes the machine had taken over the physical involvement of man and enabled him to devote his time fully to the further development of his ideas.

During this time the human intellect brought forth a great concentration of far-reaching discoveries: the discovery of X-rays by Roentgen in 1895; Marconi's invention and demonstration of radiotelegraphy in 1895; Curies' discovery of radium and polonium in 1898; Planck's evolution of the quantum theory in thermodynamics in 1900; the first aeroplane flight by the Wright brothers in 1903; the invention of the teletypewriter in 1904; the first versions of Einstein's theory of relativity in 1905; Minkowski's researches in 1908 into four-dimensional geometry, which influenced the formulation of geometrical expression of the general theory of relativity; the theoretical extension and use of discoveries made in the nineteenth century such as the theory of the conservation of energy, Darwin's *On the Origin of Species*, the discovery of a cell, and so on.

There was a faster distribution of information and contacts, development of the science of electricity, formulation of ideas about the physical and ideological basis of life, form and space.

The rationalism of the nineteenth century pictured the world within the confines of the Euclidean space full of moving forms in unchanging geometrical relationships. The phenomenological world was still observed through the inherited Renaissance perspective which was the only mode of representation of the illusion of reality.

The burden of the new scientific discoveries and philosophical concepts could not support the realistic basis of the contemporary creativity. The development of a critical attitude to the Euclidean three-dimensional space led to the construction of multi-dimensional space evolved in the theories of modern mathematicians (Poincaré). The formulation of the theories of four-dimensional space contributed to various speculations in the poetical, fictional and philosophical works of H. G. Wells (*The Time Machine*, 1895), G. Apollinaire (*The Cubist Painters*, 1913), A. Gleizes and J. Metzinger (*Cubism*, 1912) and others.

Artists and architects searched for a general reassurance and for contemporary concepts among those belonging to the past. The young generation of artists reacted against conventional thinking and tried to constitute a spiritual relationship of science and art endeavouring to perceive clearly the messages of the new

9

philosophical, technical and scientific impulses. The enormous input of realistic concepts initially created an adverse attitude. The artists reacted against the wave of technology and the rationalism which it conveyed.

The contemporary idealism was expressed by the artists' desires for the discovery of a spiritual expression of the time, for liberal ideals and for the overthrow of the functionalist era.

For them the classical school of functionalism which stemmed from the nineteenth century was unacceptable. Contemporary aesthetics required an elevation of the idea of form above the consideration of the functional element. This resulted in the rejection of historical forms and the loss of certainty of expression through an architectural 'style'.

The great search to find a way to express the feelings of the modern way of life began.

The Rise and Consequences of Rationalism in Bohemia

The basis of both modern Czech architecture and modern art was founded by the generation of artists coming on the scene in the 1890s. They realized that earlier tastes could not continue for much longer.

The large movement of population which was taking place within the country created, mainly for the proletariat, a serious housing shortage, to which was added the new problem of increasing traffic in the cities. This situation posed at least two of the problems to be solved by future designers when the struggle of the past with the present culminated. The conflict of old-fashioned academism with bright young modernism was bringing nearer the inevitable overture to the emergence of new styles.

The transition to modern architecture was reflected in the decorative Sezession/Art Nouveau style, which appeared and stood as a negation of the historical trends, showing the new power of a young generation. Yet the style was not strong enough to overcome the architecture of the previous century. The essence of the movement was still in the applied decorations derived from the influence of exotic, oriental and folklore motifs; but at least these were modern and new and not based on or copied from elements of historic decorations. The emphasis of this style was on the exterior of buildings and little change appeared within the basic layout or structure of the dwelling. The trend was not far-reaching enough and in fact it exchanged one decorative system for another without altering the basis of the system. The formal motifs were more important than spatial or functional considerations.

Nevertheless it became an enthusiastic movement leaning towards the overthrow of the persistent neo-styles and it showed the way towards the building of dwellings of the future.

In the years before World War I most of the practising Czech architects were directly or indirectly followers of O. Wagner's theories, which encouraged plan designs based on an awareness of the requirements of the new social structures, general progress, and advances in technology. Inevitably, these influential theories affected the further development of architectural taste and creativity.

After the establishment of Art Nouveau as a style, there began in Prague a new cultural movement of which Jan Kotěra (1871-1923) was the main initiator.

Having completed his apprenticeship with Wagner in Vienna, Kotěra returned to Prague at the height of the Sezession period. This immediate influence led him to create several masterpieces in that style; such as the Peterka Building in Prague 1899-1900 (Plate 1), Mánes Pavilion in Prague (1902) and the National House in Prostějov (1905-1907). Kotěra soon realized the shortcomings of this trend and his treatment of decorations and use of related forms became subservient to the consideration of function, space, technology, expression of materials and economic requirements. Towards the end of the first ten years of

the new century he lost all traces of Art Nouveau style and the new modern rationalistic approach started to play the leading role in his work, anticipating the rise of the International style.

The houses built in Prague in 1908-9 for J. Laichter (Plate 4) and himself (Plate 5) are comparable, in their concept of the new style, with some of the buildings designed by F. L. Wright during the same period and with buildings constructed fifteen years later by the architects of de Stijl. Kotěra's concept of spatial arrangements and the composition of masses was simplified and clarified since it was based on the grouping of simple right-angled elements in contrast to the predominantly curved forms of the previous period. His work stressed the importance of space and the reflection of structure in its construction as opposed to the main feature of architecture being applied shapes and decorations. New methods of construction and use of spaces produced new forms not based on aesthetic preconceptions.

Kotěra's buildings were modern, clean, powerful and ahead of their time, predicting the development of modern architectural thought. His influence was enormous and an example of this is seen in the buildings of O. Novotný, one of his pupils, whose early work clearly bears Kotěra's conceptual principles, which are particularly noticeable in his Štenc House in Prague (1909) and in the houses he built in Rakovník and Holice in 1911-12 (Plate 6).

In opposition to this rising rationalistic movement a new and highly interesting though short-lived trend of Cubist architecture suddenly appeared. Under the influence of the newly born style of painting, which was quickly transmitted by way of artists' visits to Paris, publications and exhibitions to Central Europe, a group of enthusiastic painters, sculptors and architects founded in Prague in 1911 the *Skupina výtvarných umělců* (The Group of Creative Artists). In a short while this Group published its own magazine called the *Umělecký měsíčník* (The Artistic Monthly) which was used to expand their theories. Soon Cubism became the main programme of the generation.

The reasoning of Cubist architects was influenced not only by their studies in the history of art and in the current artistic trends but also by the contemporary philosophical and aesthetic ideas of T. Lipps and W. Worringer. From aesthetic objectivism the artists tended towards aesthetic subjectivism as it is related in Lipps's theory of empathy (*Einfühlung*):

> Empathy means to objectify our sensations, to project ourselves into the insides of objects. An apperceptive motion, which creates a line, is 'empathic' into it. The act of creation of something spatial is in fact a motion. This motion is not only in our mind, but is directly experienced. It is firstly a motion of my inner operations, it is my activity.[1]

The architects investigated the problems of beauty, of space, its perception, and movement and dynamics of matter in time and space. They initiated their theories from Worringer's 'dynamic pathos of free consciousness and will penetrating into matter', and the *Einfühlung* theory.

This is confirmed in J. Chochol's statement that 'art is an expression of the innermost activity of the creative being, and in turn it is directed towards individuals of kindred dispositions and similar sensibilities'.[2]

They sought to avoid the elements of decoration and insisted that 'modern architecture does not wish for any surface ornamentation; therefore it also does not like to taint the form with detail'.[3]

The architects had not totally removed ornamentation, but they created movement in the form itself which made the ornamental function unnecessary. Their perception of space was dynamic, not at all geometrical or with a static juxtaposition of individual elements; on the contrary it appeared to be full of action, as motion was a natural source of inspiration and part of the modern sensibility. The centre of interest was the infrastructure of the material employed, and both the functionality of its use and its production were to be subordinated to it.

Reality was space, a geometrical rhythm determined by the designer's shape-forming will. One of the main aims of their programme was to effect the outer envelope of matter dynamically and this is clearly followed in their architectural projects.

What is really notable about this Cubist development in architectural creativity was the seemingly total integration of the painting and sculptural thinking into realistic architecture. It was the power of painting, of the two-dimensional canvas, which initiated the creation of the same forms in the three-dimensional building mass. Never before in the history of art had the three forms of visual creativity presented their results with so few differences in their basic interpretation of the contemporary trend. The finished house was at the same time, a sculpture, a painting and a dwelling.

Later the personalities of Expressionism, de Stijl, Constructivism and the Bauhaus movement derived their first inspirations from paintings in a similar way. Their initial efforts were based on symbolic and aesthetic concepts of architectural tasks leading to single studies, almost paintings, of buildings.

After 1907 however, the composition of Cubist paintings was the inspirational driving force, chiefly because of its strong visual impact and its modern approach to artistic creativity which bore no comparison to anything seen in the past.

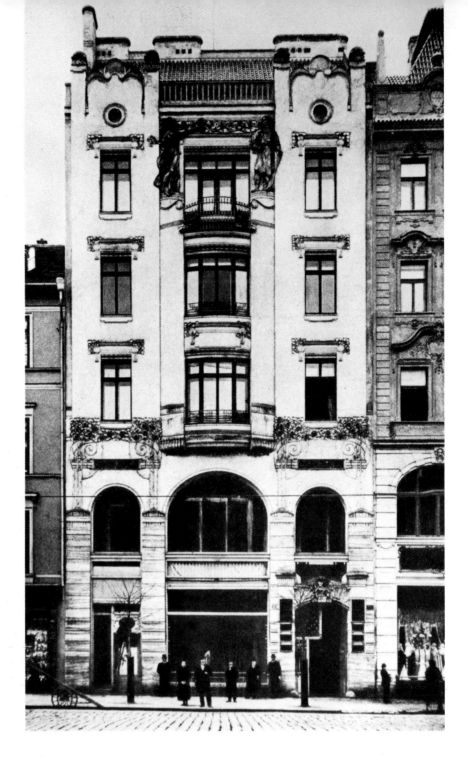

1 Peterka Building, Prague, J. Kotěra,
 1899-1900

14

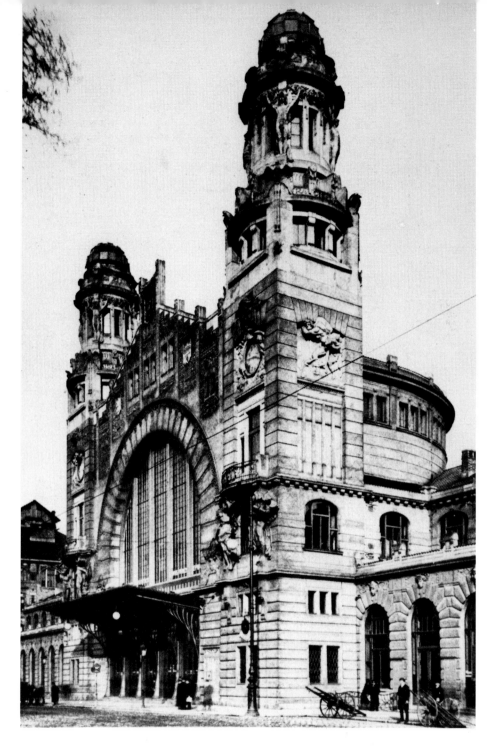

2 Main Station, Prague, J. Fanta, 1901-9

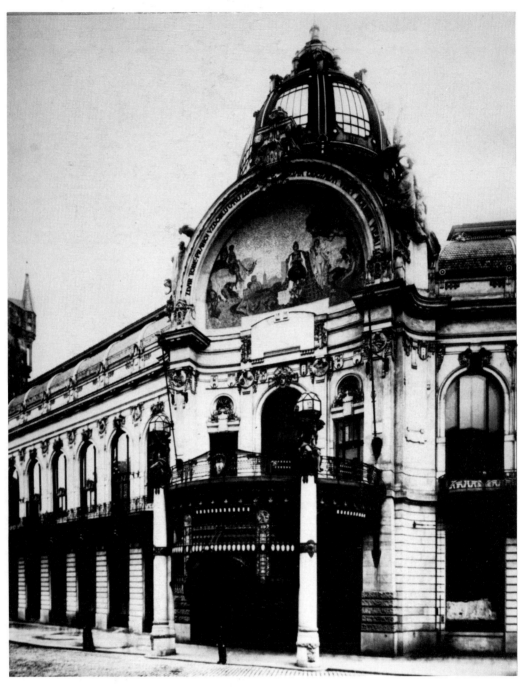

3 Municipal House, Prague, A. Balšánek
 & O. Polívka, 1906-11

16

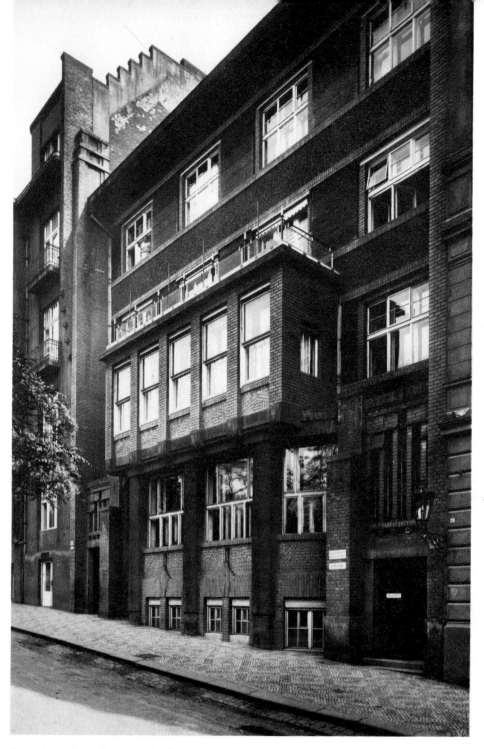

4 Laichter House, Prague, J. Kotěra,
1908-9

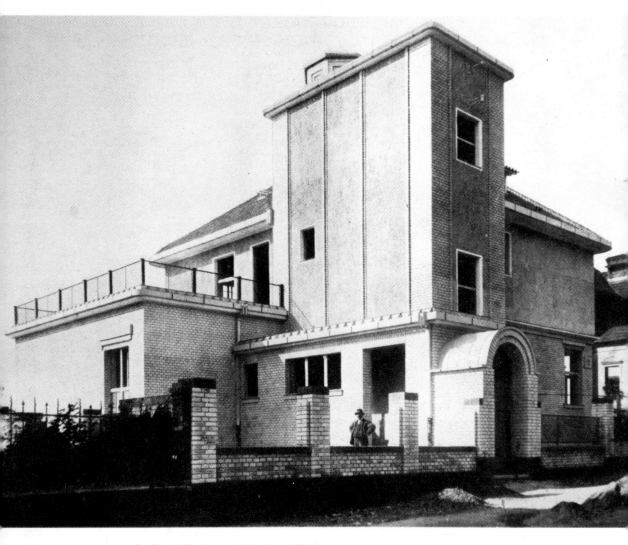

5 Own Villa, Prague, J. Kotěra, 1908-9

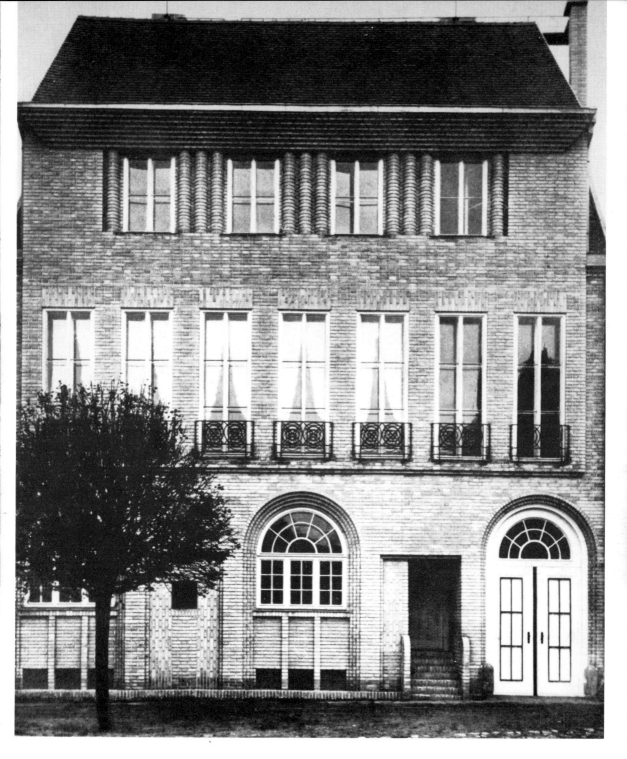

6 House, Holice, O. Novotný, 1911-12

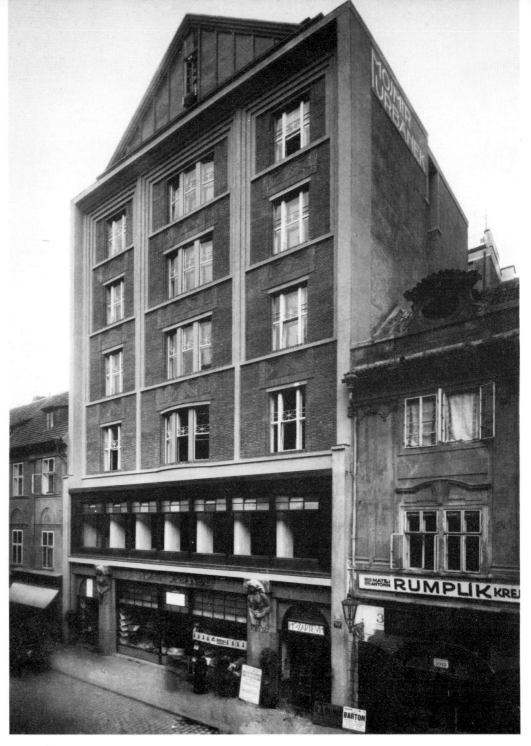

7 Urbánek House, Prague, J. Kotěra,
 1911-13

20

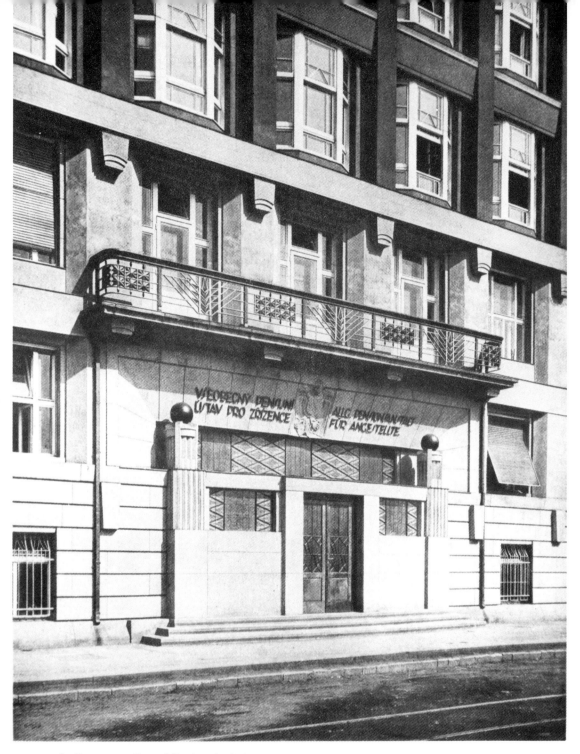

8 Entrance to General Pensions Institute,
Prague, J. Kotěra, 1912-13

French Architecture Before World War I

In France during the second half of the nineteenth century practically all pioneers of the modern movement were affected by Viollet-le-Duc's rationalist thesis formulated during his researches into Gothic architecture, that form is related to material and function. The engineers approved, when in due course architectural creativity based in concept largely on the structural form returned, endorsing their ideals. The enormous structures of Eiffel, Contamin and Arnodin seemed to confirm the theory of the essential dependence of form on function, and the new formal and spatial concepts were in fact traced back to a strict adherence to this doctrine. For example, Viollet-le-Duc's theories influenced such works as A. Choisy's famous *Histoire de l'Architecture* (1899), which approaches the history of form purely from an engineering attitude.

At the beginning of the twentieth century under the influence of the works of V. Horta the iron style in Art Nouveau reached its peak in H. Guimard's Metro station entrances (1900) and Castel Béranger (1897-8) and F. Jourdain's Samaritaine department store (1901).

The new material of reinforced concrete was discovered. There was an attempt to evolve a new style based on the use of this material and the established functionalist principles. Instead of the complicated iron structures there is an introduction of clear, strictly geometrical forms with classical overtones as in the case of A. Perret. Until the beginning of World War I the architectural use of reinforced concrete was restricted to few examples, but at the same time managed to restore the valid principle of pure structural concepts. Reinforced concrete methods based on a frame and panel system taken over from timber construction and used in a simple and honest way were applied consistently by A. Perret (1874-1954) in his buildings: which were an apartment house in the Rue Franklin, Paris (1903), the Garage Ponthieu, Paris (1906) and the Théâtre des Champs Elysées with van de Velde, Paris (1910-13).

Apart from Perret and the engineer E. Freyssinet, T. Garnier (1869-1948) aided the development of modern architecture in France the most during the first fifteen years of the century. Influenced by the academic teaching of J. Guadet and the rationalism of A. Choisy he displayed revolutionary town planning and architectural ideas based on the use of reinforced concrete in his project, *Cité Industrielle* (1901-1904) and later in *Grands Travaux de la Ville de Lyon*. Garnier invented the forms best suited to the new material, which were later to become the standard features of modern architecture. All the main concepts of modern design are not just sketched but are thought out in every detail. However, World War I prevented the actual realization of these projects.

Only Raymond Duchamp-Villon (1876-1918), the sculptor/architect, and member of the *Groupe de Puteaux*, was truly and immediately influenced by the Cubist style in painting which was beginning to emerge after 1907 in Paris. He confirmed

that 'at the beginning and without knowing them, he was attracted by the Cubist painters, and little by little could understand their aesthetic and better appreciate it . . .'.[1] He transferred this inspiration directly to architecture in his projects the *Maison Cubiste* and the *Project d'Architecture*.

Duchamp-Villon greatly contributed to the development of modern art with his sculptural studies. This contribution is reflected in his famous and dynamic *Horse* (1914), which is a sculpture embodying a machine aesthetic in powerful motion, clearly fusing action and mass, sensation and pure form in one whole object. He claimed that 'the true goal of sculpture is above all architectural'[2] and used architectural forms in some purely sculptural studies (*Head of a Horse*, 1914).

Only after the end of World War I did the truly modern style in architecture appear in France, evolving from the inheritance of the conceptual principles of space and form from the Cubist era.

The Influence of Cubist Paintings

(Cubism is a style of artistic expression in which objects are shown in distorted, unfolded, geometric forms. Perspective is usually substituted with a view of an object taken simultaneously from several viewpoints and then fused together into one composition. The objects are broken down to their basic elements and then reassembled according to the imagination of the artist into a new whole. The aim is not to abstract the reality but to show simultaneously the fullness of its form, its different facets and the complexity and structure of its components.)

Braque said of his sketches for the *Grand Nu* that it was necessary to draw three figures to portray every physical aspect of a woman, just as a house must be drawn in plan, elevation and section.[1] Cubist painters demonstrated their dissatisfaction with the perspective method of representation, which originated in the Renaissance, by adopting a physical conception of space in relation to a constantly moving point of reference. To the three-dimensional perspective they added a fourth dimension—time.

The work of art seems then to have the ability to be an organism existing on its own, expressing the emotions and spiritual affirmation of its creator to the outside world. 'Henceforth space by itself, and time by itself, are doomed to fade away into mere shadows, and only a kind of union of the two will preserve an independent reality.'[2]

Cubism reacted against Cézanne's statement, which emphasized the primacy of geometrical volumes such as those of the sphere, the cone, and the cylinder. These shapes were all curved for there are no straight lines in nature, whereas the Cubists exulted in the force and dignity of the straight line. This distinction represents a move from the appearance to the essence, from the natural to the anti-natural.

In Apollinaire's words Cubism is a geometrical construct of the mind; Cubists paint objects not as people see them but as people imagine them, and their art is extremely lucid and pure. Thus this style could be defined as an artistic expression based on the spiritual rather than the physical truth or circumstance.

The first painting showing recognizable Cubist elements is attributed to Pablo Picasso (1881-1973). In 1907 he painted *Les Demoiselles d'Avignon* (Plate 9) under the combined influence of Cézanne, Matisse and African art. The painting, which is full of flat planes almost without any shading and with crude outlines of facial features, limbs, and breasts and broken up perspective, heralded the arrival of the new era.

In a short time his friend Georges Braque (1882-1963) started to see the merits of the work. He was the first, in 1908, to publicly exhibit his Cubist paintings—*Houses at L'Estaque* (Plate 10) in 1908 in the Kahnweiler Gallery and later in the same year in the Salon des Indépendants. The critic L. Vauxcelles in an article in *Gil Blas* mentions, in describing the paintings, the word 'cubes' for the first time.

Picasso and Braque worked together and the truly Cubist paintings, starting with landscape themes, came into being. Cubism was principally approached through landscape due to the effect of Cézanne and the Impressionists whose main interests had lain in that sphere. But once the pattern of Cubist composition had been established in 1908 this theme quickly changed to views of still life. The still life subject seemed to the artists less complicated, more readily observable and more intimate. The problem of perspective was removed because of the nearness of the painted object.

Anal.

There were two basic phases of Cubism in painting; in the analytical phase (1909-1911) the object was broken down, examined and distilled to elements of structure. In Synthetic Cubism (1912-1914) pure forms were used to engender their own vocabulary, even, and this was realized in the Cubist collages, to create

Synth.

objects of their own. The ingredients of a collage actually play a double role. Their function is to be both a part of an image and to be themselves, thus endowing the collage with a self-sufficiency that no analytical Cubist work can have.

The paintings and collages of Picasso and Braque were intended not as idealistic copies of reality but as a kind of dramatization of the processes by which natural forms were translated into art. Though their subject-matters were always taken from nature, artists insisted that the painting had to be able to stand on its own independent of the object portrayed.

One of the basic meanings of Cubism is that a work of art depends both on the external nature of reality and the inner reality of art. In Cubism there is always a dialogue between the reality and the work of art; the ambiguous playing of one against the other which confuses the observer. The Czech painter E. Filla said that Cubism has a tendency to express static and dynamic states at the same time; the pictured object is restful in its final appearance, but with its spatial virtue it has an expression of movement if only in our imagination.

The Cubist method of work based on spatial exploration resulted in making the architects think in terms of volumes, that is of space defined by planes, instead of in terms of mass and solidity which was what they had been taught until then.

Space in modern physics is conceived of as relative to a moving point of reference, not as the absolute and static entity of the Baroque system of Newton. And in modern art, for the first time since the Renaissance, a new conception of space leads to a self-conscious enlargement of our ways of perceiving space. It was in Cubism that this was most fully achieved.[3]

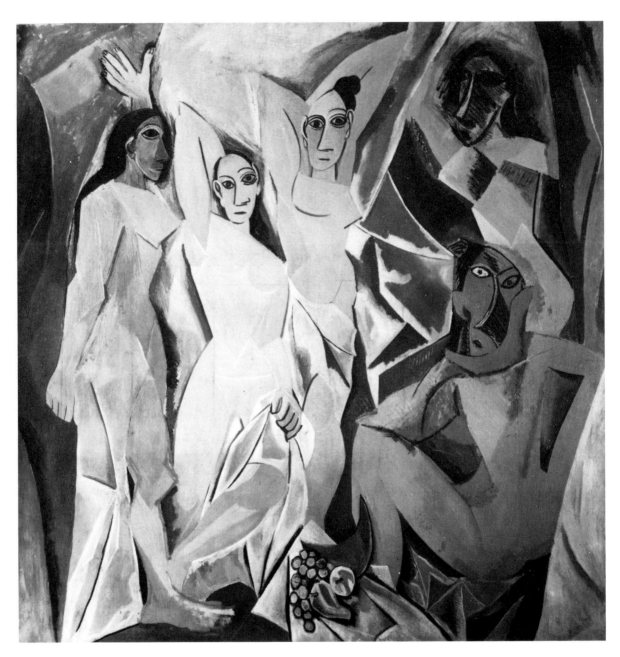

9 **Les Demoiselles d'Avignon,**
Pablo Picasso, 1906-7, oil on canvas,
2440 x 2340mm, Collection, The
Museum of Modern Art, New York,
acquired through the Lillie P. Bliss
Bequest

10　**Houses at L'Estaque,** Georges
Braque, 1908, oil on canvas, 730 x
595mm, Kuntsmuseum Bern,
Collection Hermann Rupf Foundation

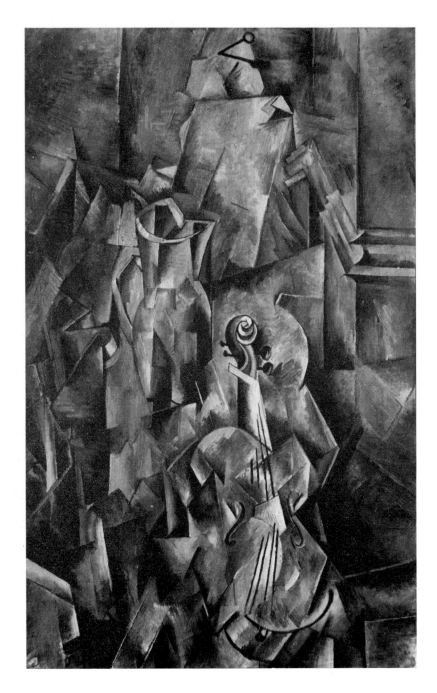

11 **Still Life with Violin and Pitcher,**
Georges Braque, 1910, oil on canvas,
1170 x 735mm, Kuntsmuseum Basle

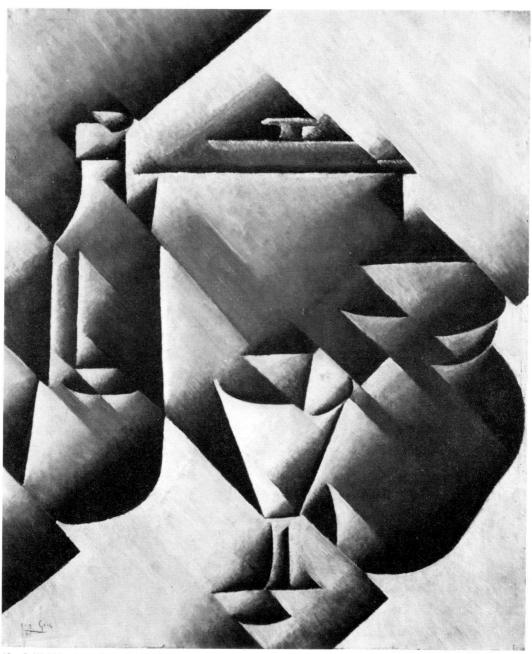

12 **Still Life,** Juan Gris, 1911, oil on
canvas, 597 x 502mm, Collection, The
Museum of Modern Art, New York,
acquired through the Lillie P. Bliss
Bequest

29

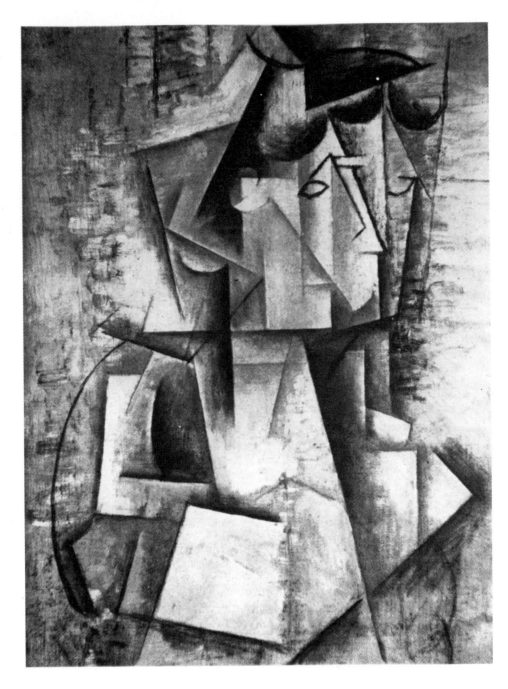

13 **L'Arlésienne,** Pablo Picasso, 1911-12,
oil on canvas, 740 x 540mm,
Collection W. P. Chrysler Jnr.

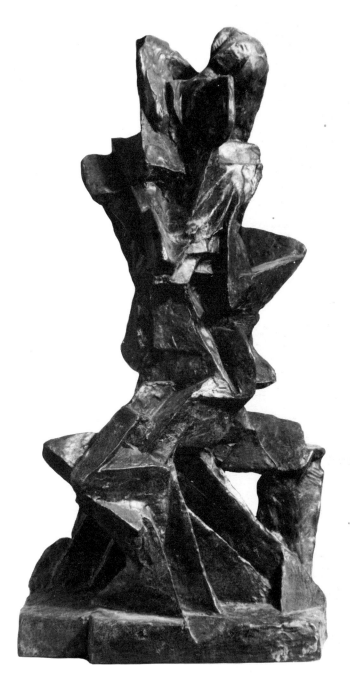

14 **Embracing Figures,** O. Gutfreund,
1912-13, bronze, 660mm high,
National Gallery, Prague

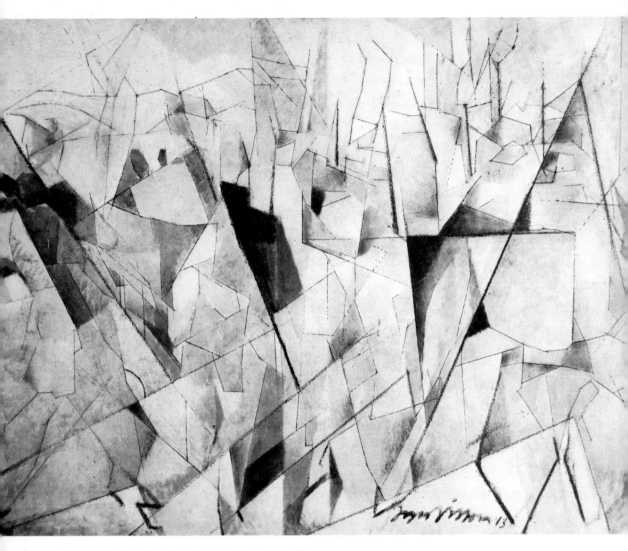

15 **Marching Soldiers,** Jacques Villon,
1913, oil on canvas, 648 x 917mm,
Musée National d'Art Moderne, Paris

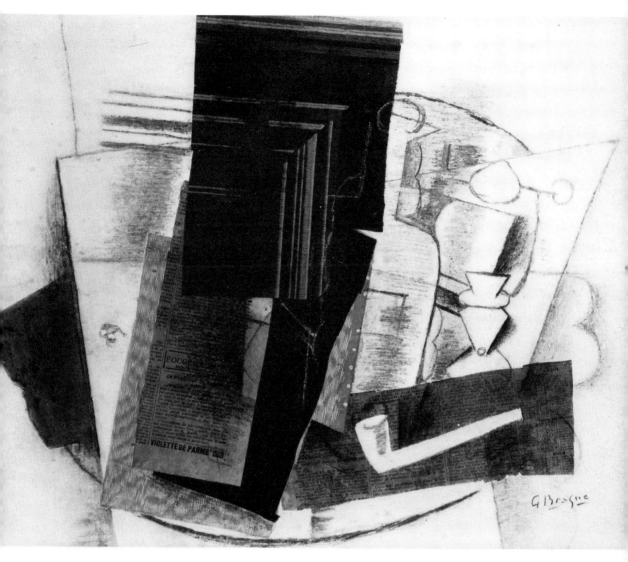

16 **Bottle, Glass and Pipe,** Georges
Braque, 1914, collage, 480 x 586mm,
Collection Lady Hulton, London

From Rationalism to Cubism in Architecture

The first signs of the Cubist trend in Czech architecture could be seen in the remarkable Wenke Department Store in Jaroměř (Plates 17 & 18) which was designed by Josef Gočár, a student of Kotěra, in 1909. The building is very interesting for its time as it shows one of the first examples of a curtain wall application. The façade, three storeys high is based on a notion of the theatrical side scene. The treatment of the top storey is totally different from that of the lower ones and it is in this part of the building that the signs of Cubism can be observed. The thick fluted columns with dark spaces in between and the light railings with the diamond and triangular motif suggest the coming style. Despite the different treatment of the two parts of the façade they complement each other and result in a magnificent entirety.

From 1903 during his studies with Kotěra, Josef Gočár (1880-1945) was encountering the general field of architectural creativity which was still under pressure from the Art Nouveau style. But he was soon instructed to proceed towards the rationalistic, functional approach. His first works after leaving Kotěra's atelier in 1905 were still marked by the Sezession decorations but his own concepts of clean cut architectural form were developing, as is shown in the project for the Sanatorium in Podolí and in the staircase to the church in Hradec Králové (1909). After finishing the Wenke Department Store Gočár also worked on interior and monument designs, where he exercised his skill in investigating and experimenting with new forms and masses, together with their implications for practical and aesthetic functions.

In the 1909-10 design for the interior of the apartment of Dr J. Gregr (Plate 19), Gočár purposely used for the first time cut and sloping planes with diamond and pyramid patterns, thus trying out some of the tools of Cubism and suggesting a sudden acquaintance with new totally different, influential elements.

The progress of Rationalism started with Kotěra's later work, and the projects of Gočár and Janák begun before 1910 unexpectedly stopped, transferred or sidestepped into the Cubist trend.

Pavel Janák (1882-1956), the other major personality involved in the rise of Cubism, published several articles in 1911 and 1912 in the *Umělecký měsíčník* which set out the principles behind the theory of architectural Cubism.

Janák also started his studies in Vienna with O. Wagner and worked on several projects with Kotěra. Like Gočár, his progress is marked with an even faster shedding of Art Nouveau and a faster development of the rationalistic approach. This is shown in his early projects for the Palacký Square in Prague in 1907 (Plate 20), the new Staroměstská Town Hall (1909), the Tunnel to Letná in Prague (1910), and the realized work of the Weir at Obříství (1911). This project is especially interesting for its severe logic based on the functional element when stretched to its utmost limit. The setting in the landscape seemed to be taken as

analäsis

the primary task of the architect with the reinforced emphasis on forms without any decorative details. The composition is cool, clean and almost static.

analis

The next work by Janák, the Hlávka Bridge (Plate 21) in Prague (1909-1911), was a creative milestone for him. The architecture is not cool and unmoving. There is dynamic movement in the wavy form of the edges of the arches, the motifs of the pylons, and in the obliquely formed walls where the bridge leaves the riverbanks. The basic composition is strictly founded in the rational approach but Cubist tendencies are already present in the detailing of the pylons, arches and the positioning of sculptures (by O. Gutfreund). This new concept did not occur to Janák without foundation. His work was always based on his theoretical notions, which justified his involvement in any specific approach to architecture.

Janák argued that the present rational, functional, constructional and structural concepts were too narrow and without compromise, and that they displayed a character which was too clean and almost anti-social.[1] He proclaimed his stand for more theory and a return to the appreciation of the past with more 'architecture' rather than modern style. He called for a creativity in which artistic thinking and abstraction would take a lead over the functional concept and would progress further in trying to put forward plastic form and plastic realization of architectural concepts:

> The upsurge of architectural creativity, defined as the governing, spiritual and formulating creativity, corresponds to the silencing of the material and constructional element and their subordination to artistic intention . . . we are putting our own abstration of idea and form above the individual characteristics of material, and reckon without respect, with the strength and loading capacity of material, thus putting the material under certain strains and tensions in our effort to elevate ourselves to the ideal concept.

Janák calls for discipline and unity in architectural design:

> We need a new theory. There has been enough poetry in modern architecture but too little of architectural beauty. Poetry improves architecture only by adding details, but architectural beauty must be constructed, and we reach it through the structure of the material. Architectural beauty is a dramatized balance of materials. Olbrich and Hoffmann used ornament, where we feel there should have been a plastic form. The creative mind and abstraction will take the place of the previous predominance of purpose [decorated by poetic details], and architecture will continue in its efforts for the plastic form.

These were the first theoretical outbursts against the new rationalistic trend and the beginning of the sidestep to Cubism.

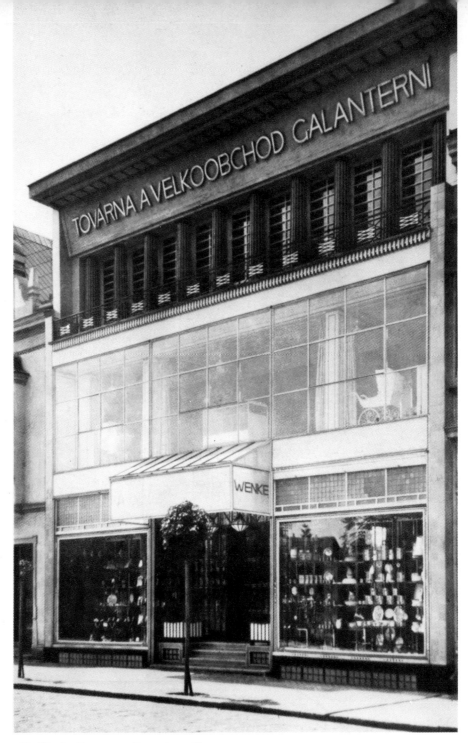

17 Wenke Department Store, Jaroměř,
J. Gočár, 1909-10

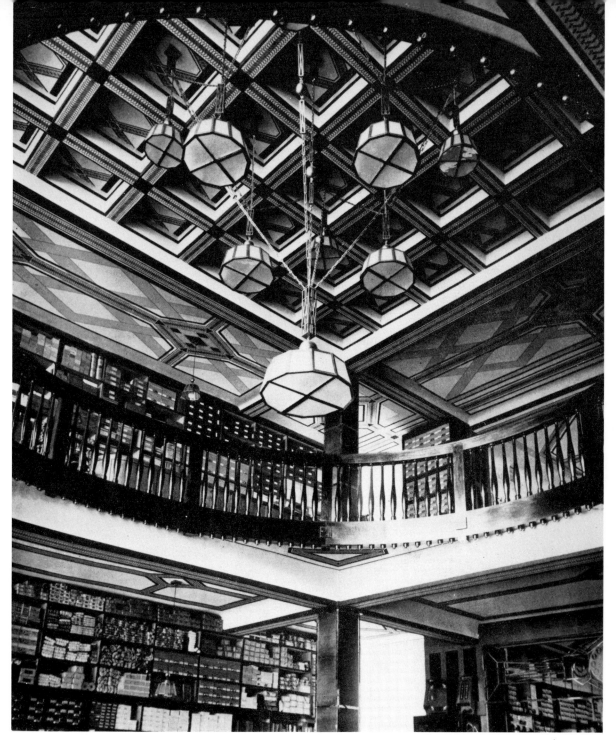

18 Interior of Wenke Department Store,
 Jaroměř, J. Gočár, 1909-10

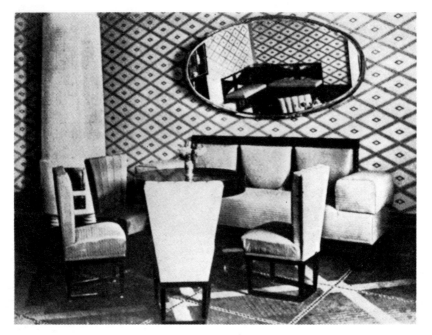

19　Gregr Apartment, Prague, J. Gočár,
　　1909-10

20　Project for the Palacký Square, Prague,
　　P. Janák, 1907

38

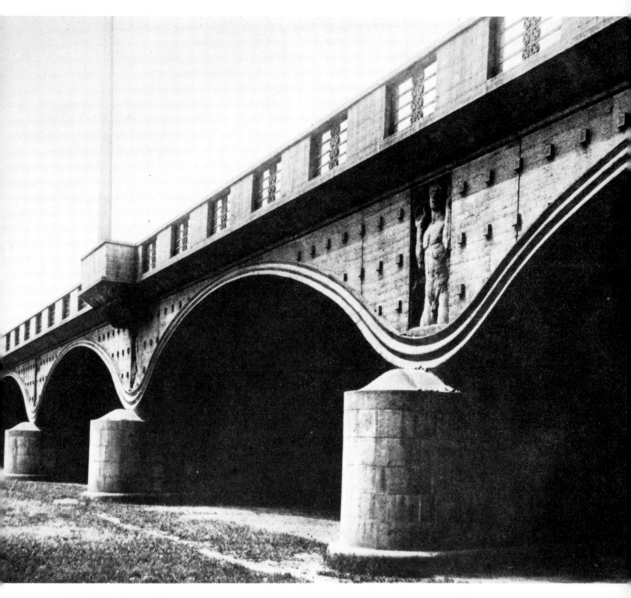

21 Hlávka Bridge, Prague, P. Janák,
 1909-11, sculptures by O. Gutfreund

Cubist Theoretical Writings

In February 1911, under the newly developed influence of Cubism in France, Czech painters, sculptors, writers and composers E. Filla, A. Procházka, V. Beneš, V. Špála, J. Čapek, O. Gutfreund, V. H. Brunner, V. Dvořák, Z. Kratochvíl, F. Kysela, F. Langer, V. Rozsypal, L. Šíma, V. V. Štěch, J. Thon, M. Urban and others formed a new group called *Skupina výtvarných umělců*—The Group of Creative Artists—and isolated themselves from the members of *Mánes* who were unable to conform to the new ideas as their views were based on the traditional outlook of visual arts. The new group was joined, at the same time, by architects Gočár, Janák, Josef Chochol and Vlastislav Hofman. With the aim of proclaiming and expanding their ideas they used the magazine *Umělecký měsíčník*, which was founded by the group.

The most important articles expressing the new ideas were Janák's[1] and in his writings he put forward a thesis that architecture can be conceived as art only if the form emanates from the spirit of the current era. This spirit, whose 'mind turns matter towards abstraction', suggests that the creative process is governed solely by the geometric conception of forms. The Greek, Gothic and Baroque styles used elements based on prism or pyramid forms. Cubist architecture is related to both and is based on a positive relationship with mass and a materialistic notion of art. When architecture deviates from this direction it loses its meaning. The new trend is concerned above all with form; its material is not considered important; we only see the form. Based on plastic conceptions the world of forms is not dependent upon what it is made of. This is why colour is suppressed as well.

> . . . we do not see any materials, we see only the mass in everything. In the world of forms ,which is based totally on the plastic notions, it is unimportant in which material—be it expensive or common—they are realized. The self-colour and colour simplicity is rather welcomed and materials which have this characteristic are preferred, since in them the plastic relations mutually act more clearly.[2]

Janák says in 'The Prism and the Pyramid' that an architect collides with the corporealness of dead matter and copes with it by hewing corners and edges, thus penetrating into its depth wherever he does not acknowledge or empathize with it. These changes, which his artistic sensitivity imposes upon matter are of non-natural origin, hence they are no longer, as a rule, derived from the bi-planar system—horizontal and vertical, but improve and alter matter in the sense that they dramatize it primarily with the aid of a third element—a diagonal plane.

This dynamic principle of the diagonal is the main motif—an animating element to complement the vertical and horizontal planes. The main feature is solidity, compactness, composition of forms, the dramatization of the equilibrium of

forms. The weight, material and function used to be thought of as the main influential elements of the character of architecture; often they became also the parameters of criticism of architecture. It is shown that apart from this conceptual importance, which had been ascribed to them, it is even possible to observe that architecture is trying to overcome the obstacles, created by the weight, material and function.

Janák says further, that in trying to discover the essence of the present era, architects should try to bring their design concepts closer to subjectivism and abstraction.

He defines two approaches to architectural design in 'The Façade Revival'. In the first, the observer is supplied immediately with objective and tangibly accurate knowledge of the form and space, such as in the space of a central plan. The second approach, which demands the active participation of the spectator is exemplified by the relationship between a longitudinal plan and its façade; here the façade supplies only limited knowledge of the space behind but gives important hints. Thus, for example, the blank arcades on the façade of San Michele at Lucca define the dimensions of the church, and by using our visual perception they create an impression of the space behind—as if we were looking at a bas-relief. Baroque took this idea a step further; the façade elements which had previously been mere additions to the internal space now combined with it to create a new unity, some elements thereby becoming more important and some being reduced to a secondary role.

Before the third dimension was actually exploited, the Baroque style used tricks of perspective. Even the central plan was expressed through a façade, as in the church of St Charles Borromeo in Vienna, or Kilian Dienzenhofer's church of St Nicholas in Prague. Janák further states that: 'Space is always three-dimensional, but it is necessary to add to it; space must be created by the plastic shaping of its limiting surfaces.'

As to the design of Cubist furniture Janák expressed the view that in the past furniture used to be a natural object, which did not contain any clear, free intellectual activity of man. In order to achieve the latter, both technology and creativity must be present in the object at the same time, one overlaying the other. This is why the resulting object gives a rich impression of fullness and tension which purely constructed things do not have. There are two elements in such an object, both on and under the surface, one is the mass moulded into a useful form, and the other is the surface shaped to create certain visual values. With ordinary furniture these two elements are neutral, resting side by side but in Cubist objects they are moved one against the other creating further relationships, new structures and new contrasts. Thus the intellectual, artistic structure of an object is raised above its natural form.

The silhouette of a piece of furniture expresses 'a mental effort to take hold of the mass round all sides . . . and master it through our sensibility by lending it a form according to the wishes of our heart'.

He further says in order to emphasize the supremacy of form above the technical and functional requirements that

> formerly in the era of applied art, it was felt that the constructive aspect, ie how the furniture is put together from the maker's point of view, was most important, and it emphasized the external parts of which the piece consisted. Now . . . it is quite unessential to consider the construction as a sum of the individual parts: what we must bear constantly in mind is the material as a whole in which . . . the legs, rounds and rungs, for example . . . are considered as nothing but articulated matter.[3]

V. Hofman expressed similar views to those of Janák[4]. Every composition starts with and takes further something already given, or something which it intends to become. But in order to create a live formal character it is necessary, beforehand, to institute the impulses and stimulations which lead to this expression. Modern architecture already has one major characteristic, which is an inner one, and not yet a purely formal one. The psychological characteristics of architecture are carried forward by the human intellect and the formal interpretation is given by the actual method of creation. Hofman further said that to formulate architecture it is necessary to understand the bulk and tension of the conceived imperfect and distorted forms which our mental reflection puts in motion. Surface planes express not only the content, but the motion relative to the substance of an object:

> From the fundamental standpoint, to create architecture means to put matter in motion. The aim is to create form which is restful from the motion of matter. It is then a principle based on the sensation of excitement and spiritual motion, in comparison to the opinion of classicist theory, which stands on reason and intellect only.

In another article[5] Hofman says that the present rationalism overstresses the exclusive functionalism and utilitarianism in architecture and gives it instead of rules and laws mere schemes which lack formal elements and which are built only on the basis of scientific formulae. At least the architecture which evolved in this period of new inventions has not developed a psychological relationship with the environment, as clearly or correctly expressed, as the engineering structures did with their technical products, which carried fully the impression of the new era and appeared so self evident that they do not need to be called modern to be differentiated. In comparison the effort to create modern architecture carries

with it the search for formal expression, this is because the concept of form is different from that of function. Indeed, it appears that form should determine function rather than the other way round.

Articles by Janák and Hofman were what formed the real programme of the new trend. Their theories concentrated on 'the problem of form . . . which differentiates the space and integrates a new one, a new architecture, as a newly born object in the world, created artistically'.[6] This new art was entirely different and not at all associated with then reigning Rationalism.

The young painters and sculptors in the *Skupina* followed fairly closely and without major deviations the inspiration which stemmed from the Cubist style, which had appeared from abroad. The architects however, developed their own style, wholly different to anything which had been seen before. It was the direct contact with the representatives of other visual arts in the *Skupina*, which had strongly stimulated the creative minds of the architects. This unique opportunity for discussion, criticism and self-analysis based on a shared interest and guiding force, together with freedom from the presence of the older generation, enabled the young idealism to expand.

Architects rejected rational, realistic thinking as a guide for their creativity. Rationality which had been based on realistic tendencies was substituted as a leading force by the all-governing power of the human mind. The aim proclaimed was the dynamic and dramatic movement of the form, which had to be artistically overpowered through one's inner being. 'We want to substitute ornamentation for the intellectualized liveliness of form. What we condemn in decoration and ornamentation we try at least to reach with the power of concentrated and total effect marked with the taste of mathematical precision, rugged austerity and vigorous strength.'[7]

The new trend was truly filled with a romantic and idealistic spirit. This approach led more easily to abstraction, where the play of light and shadow moved the prismatic, cut forms, and also led to the disregard of functional principles, human needs and proportions. The enthusiasm to explore the theories in practice had taken over.

Duchamp-Villon and the *Maison Cubiste*

The only following similar to the Bohemian movement appeared in the work of Raymond Duchamp-Villon (1876-1918) in France in 1912. His *Maison Cubiste*, a mock-up of a façade, displayed a plastic treatment of the mouldings above the entrance, the windows, and of the gables. In essence his work was concentrated mainly on plastic ornamentation applied to the fabric of an established building rather than in attempting to achieve an overall concept of modern architectural form.

By 1911 the profound innovations of Cubist concepts had spread beyond the immediate circle of Picasso and Braque to a group of artists who began to meet regularly in that year at Villon's and Duchamp-Villon's studios at Puteaux.

The group, which exhibited later, in 1912 as the *Section d'Or*, included the Duchamp brothers, Marcel, Jacques, and Raymond, F. Léger, A. Gleizes, J. Metzinger, J. Gris, F. Picabia, R. Delaunay, A. Lhote, F. Kupka, R. de La Fresnaye and on occasions they were joined by G. Apollinaire, A. Mare, R. Allard, A. Salmon, A. Mercereau. All matters of current interest were discussed: art, philosophy, literature, poetry, photography, theatre, mathematics and other sciences.

During 1911, as the new trend was adopted by the Puteaux artists the group came to look upon themselves as independent and separate from Picasso and Braque. Their major difference, apart from variations in the formal elements of Cubism was in their attitude to the relation of the new style to the enormous changes which were brought on by modern life. While Picasso and Braque concentrated only on stylistic problems, the Puteaux group tried to relate Cubism to the epic themes born of the dynamism of a new era. Duchamp-Villon particularly became conscious of the need for an art which was appropriate to the twentieth century.

For the 1912 Salon d'Automne Mare asked Duchamp-Villon to design a façade that would unify the exhibition's general interior decorative scheme. During the months preceding the Salon the group met once a week to discuss their designs. At Puteaux, with the help of his brothers, Duchamp-Villon worked on a full scale façade, later called *Maison Cubiste* (Plates 22 & 23).

The façade was based on a traditional style in order to demonstrate the adaptability of the plastic treatment to a wide range of architecture and building types whether already existing or yet to be constructed. Duchamp-Villon's conception was motivated by a real sense of the need to relate a new architectural order to the existing environment.

Duchamp-Villon felt that architecture served as a framework for all the arts, permitting their cohesion within a logical grouping and thereby incorporating them as an integral and practical part of society's daily life.[1] This concern of the relation of art to reality was an essential part of the communal spirit from which the *Maison Cubiste* arose.

The main outlines of the façade resemble those of the Théâtre des Champs-Elysées, which was under construction during this period. H. van de Velde was the architect for the Théâtre together with A. Perret, who was the pioneer of the use of reinforced concrete. Perret was a friend of Duchamp-Villon and a frequent visitor to Puteaux. Duchamp-Villon said that the design of the *Maison Cubiste* was suggested in part by the new developments in the use of concrete and steel in building construction and he generally expressed his admiration for the Théâtre.

The most significant aspect of the *Maison Cubiste* was the plastic treatment of certain parts of the façade.[2] This was inspired by natural phenomena such as the pattern of icicles, which formed the basis for the shapes over the entrance. The central ornament on the second floor which was based on interesecting prismatic forms, was an abstract translation of the sun and its rays of energy. It was held together by what Duchamp-Villon called the 'living line', which passed through each form and converged at a point directly over the pediment. This point corresponds to what he later described as: 'a plumb line, motionless, suspended in the centre of a free space. It is the purest element of sculptural language about which man has a certain indispensable, inexplicable idea. This harmony, absolute and concrete, makes a point of infinity tangible for man.'[3]

The precision of the geometric conception of ornamentation and the façade suggests that Duchamp-Villon may have employed the golden section. The golden section served as a method of unifying the overall dimensions with separate plastic elements. The proportion of elements was discussed at Puteaux in an effort to attain a more rational, less intuitive basis for their art.

'It is almost droll the pleasure I have in arranging simple square blocks, the one with the others, until I have found the relation of forms and dimensions',[4] said Duchamp-Villon of his design for the *Maison Cubiste*. He further says:

> We must establish new decor of architecture, not only in the characteristic lines of our times, which would be but a transposition of these lines and forms in other materials, and which is an error. Rather we must penetrate the relation of these objects among themselves, in order to interpret, in lines, planes and synthetic volumes, which are balanced, in their place, in rhythms analogous to those of the life surrounding us.[5]

The arrangement of the geometric shapes designed by Duchamp-Villon is analogous to the closed forms of Cubism, and by breaking with the realism of modelled forms he approached a new range of expressive possibilities, which could fulfil his ideas of portraying the ways of modern life in a suitable manner.

In 1914 in response to a request from his friend W. Pach to work out a design of sculptural ornamentation for a new college dormitory to be built in the United States, Duchamp-Villon designed a model *Project d'Architecture* (Plate 24) and

delivered it to Pach. Regretably the project was rejected by the college. Here Duchamp-Villon employed a Gothic style of architecture as the setting to demonstrate that the designed plastic ornament was suitable for any type of building style. His new modern ornamentation, he felt, could be adapted to the Gothic without disrupting its inherent unity. There is here an attempt to correlate elements of Gothic building to a modern structure, thus continuing the efforts of Viollet-le-Duc, V. Horta and H. P. Berlage who had all made similar attempts to apply the principles of Gothic architecture to modern materials and problems.

In the three rows of decorations Duchamp-Villon designed a motif based on the heavens; the upper row represented the planets, the middle one the stars, and the lower level the moon and its rays. The orientation of the designs was essentially realistic as, 'the pleasure is in finding motifs which have their origin in life, no matter how abstract the realization may appear'.[6]

The formal elements of these motifs derived to a certain degree from the *Maison Cubiste*. The prismatic shapes in the second row for example were applied as a single form isolated from the central ornamentation of the *Maison Cubiste*. They enabled him to improve and extend the formal distribution of architectural elements in increasingly abstract circumstances.

In the overall context the French projects were not taken far. Rather only the ornamentation and decoration of Baroque, Rococo or Gothic have been substituted for the new Cubist motifs, leaving the architecture of the main form of the façades still following these past styles. There has been no attempt to find a new totally modern expression of architectural form.

The Czechs took the Cubist tendencies much further, freeing themselves from the past styles. Their works were projected in their entirety within the new concepts rather than being applied to already established building forms.

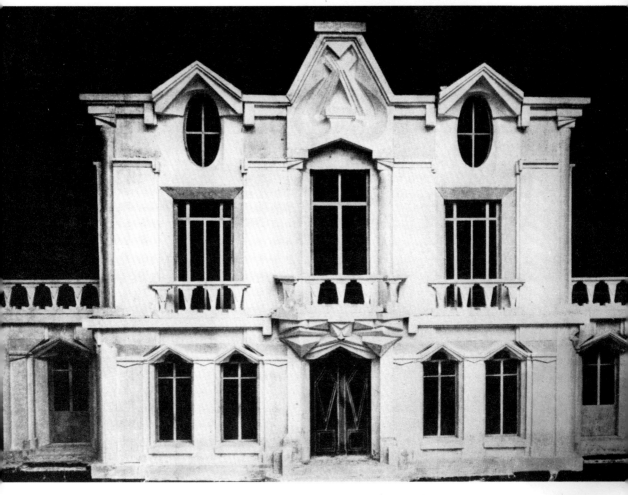

22 **Maison Cubiste,** R. Duchamp-Villon,
1912, plaster model, dimensions and
whereabouts unknown

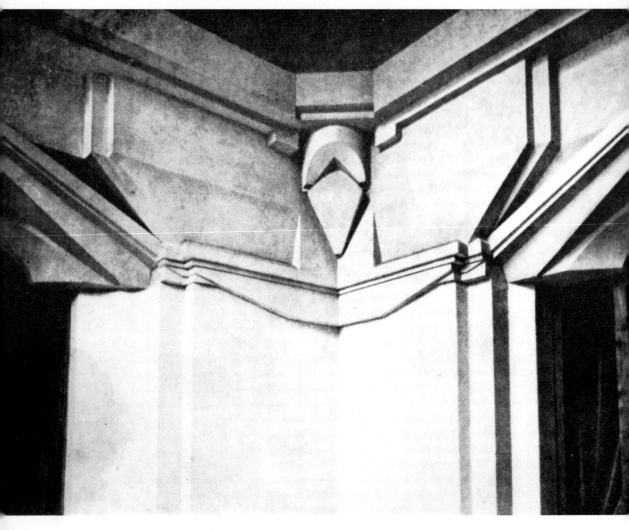

23 **Maison Cubiste,** detail, R. Duchamp-
Villon, 1912

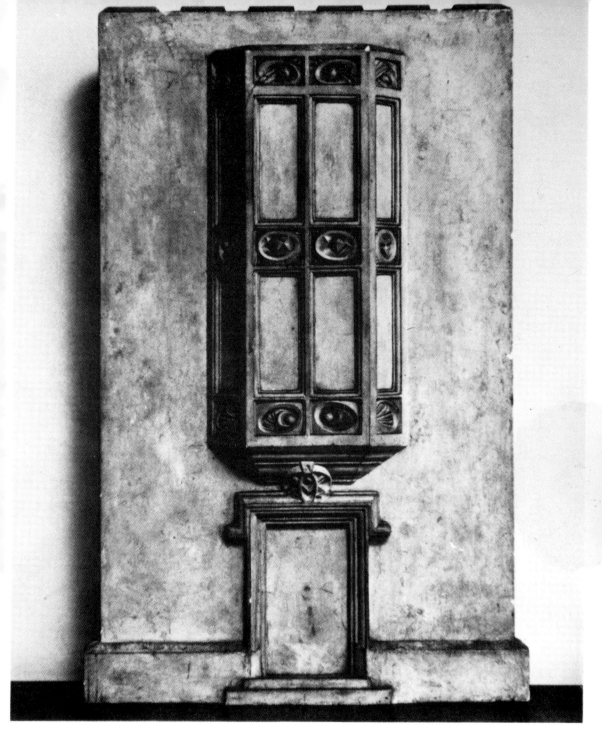

24 **Project d'Architecture,** R. Duchamp-
Villon, 1914, plaster model, 560 x
340mm, Collection Mrs W. Pach

49

Cubist Buildings and Projects in Bohemia

Gočár's sketch for a Theatre in Jindřichův Hradec (Plate 25) in 1911-12 already showed fully all the aspects of Cubism, the almost total breakdown of massing, the dramatization of movement underlining the play of light and shadow which was created by the intersection of slanting flat planes.

The realization of the Sanatorium in Bohdaneč (1911-12) was a triumph for Gočár (Plates 26, 27 & 28). At last there was a chance to observe Cubist architecture at its best. The plan of the Sanatorium was based on a horizontal spread of individual spaces resulting in long low façades. The western façade especially allowed itself to be moulded into dynamic compositions of Cubist elements. A single motif of distorted French windows with a complementary pattern multiplied in the horizontal row created the feeling of symmetry and rhythm frozen in one total entirety. The symmetry of the horizontal arrangement was weighted down by the heavier semicircular centre and its smaller reflections at each end. Gočár has managed to realize the theories put forward in Janák's articles though only in the involvement of the external elements and their immediate effect on the interior. The general arrangement of the plan of the inner spaces was fairly conventional. Nevertheless the exterior treatment gives the feeling of total balance of the elements of colour and form.

His next work was the Apartment House of the 'Black Virgin Mary' (Plates 29, 30 & 31) in 1911-12. This building was designed for an infill site and was therefore a more difficult problem due to consideration of the surrounding historical area. The value of the architecture of this building should be appreciated that much more, as Gočár has attempted, with success, to incorporate it into the character of the location without resorting to the past styles.

The resulting building was designed with great sensitivity both for mass and detail, making it perfectly fit for its situation. The main entrance brings the immediately surrounding broken surfaces and the criss-cross railings into the interior. The panes of the first and second floor windows bulge over the street, the recesses undulating between the slim piers. The Mansard roof in two tiers with its marvellous dormer windows caps very suitably the lower heavily graduated rhythm of the horizontal levels of the storeys.

Janák's creativity, which fell within the Cubist period, took place between the years 1911-14. Some of his involvements, different from Gočár's, were projects concerning the reconstruction of historical buildings. There was the reconstruction of the Town Hall in Havlíčkův Brod (1912-13) and of the House, No 13, in Pelhřimov (1913). In the unrealized project for the Town Hall (Plate 34), in Havlíčkův Brod, a provincial and historical town, the façade of the building is treated with subtle motifs creating only a notion of movement rather than a dynamic excitement. The motifs generated by the gables spread down towards the ground diminishing in their strength and are repeated on a smaller scale

50

again above each window. The balcony grows directly from the main body of the building and terminates on the corner in a little hexagonal tower, which becomes an indispensable part of the design.

On the other hand the House, No 13, in Pelhřimov (Plates 35 & 36) reinforced the Baroque tendencies of Cubism. The house is moulded within its historical framework using similar motifs to those of Baroque. The additional excited dynamics of the exterior fully fill in the gap between the styles rather than providing contrast with the new work.

This showed that the adoption of Cubism for restoration work of this kind can really only improve the image of the past if used with sensitivity, and if it is in keeping with the original style. Additionally Cubist elements are in perfect harmony with the architecture of the building, and reach the utmost limit, which is something lacking in the original façade. Cubism in this application is totally justifiable.

The unrealized project for the new Cooperative Housing in Pelhřimov (1911) was obviously different from the reconstruction work. The plans of the houses were based on modern requirements and to fulfil these the Cubist principles were left entirely to external application. Mainly affected are the roof gables, the shape of the chimney and the roofs, the cut off corners and columns, the sloping external walls, the fence details and the window surrounds. It was impossible to apply Cubist theories to the general planning of the interiors. The architect was fully aware of the destructive nature of the style which would make the resulting volumes difficult to live in.

The dream of involving Cubism in architecture, in all aspects of the three-dimensional mass of buildings, was hardly ever realized and only paper projects remained. One of these was the incredible competition entry by Janák and O. Gutfreund, a sculptor, for the Žižka Monument in Prague in 1913 (Plates 37, 38 & 39). The end product was a triumphant Cubist form. The two artists cooperated to create a fantastic composition of crystal-like forms heaped on top of each other revealing in the centre the super-human figure of Žižka. The monument was a sculpture in its whole essence and showed how far the dedication to Cubism could depart from practical reality.

The number of Josef Chochol's (1880-1956) works in Cubism were limited but included three outstanding examples—a Villa and two Apartment Blocks in Vyšehrad, Prague (1913).

The Villa (Plates 43 & 44) is especially interesting. The Cubist forms and elements were varied and new and not based on any historical precedent. But most of all Cubism did not stop with the façade but spread into the plan and effected the execution of the surrounding garden and fencing. This distortion of the horizontal layout added a further dimension to the whole complex which was

reinforced with every detail. In the Apartment Block (Plate 45) similar plasticity to the Villa was employed together with the Mansard roof which seemed popular with the Cubists because of its basic form and the easy inclusion of dormer window elements. The Apartment Block in Neklanova Street (Plate 46) shows an original solution for a building situated on a corner site.

Apart from his theoretical works Vlastislav Hofman (1884-1964) was famous for his Cubist furniture and interior designs, of which some had almost Gothic qualities; the interiors which are suggestive of folded fabric, were supported with themes taken from cemeteries and monuments.

His building projects, which consisted mainly of façade studies, were stretched to the limit of possibility and as a result very few of them have been realized. Nevertheless Hofman's projects showed the wide base of the style where no building type or object escaped the attention of Cubists wishing to prove their skill.

The only person to extend Cubism in architecture beyond World War I was Jiří Kroha (1893-). By then the work of others had developed into the post-Cubist trends of the National Decorative style and Rondo–Cubism. The rise of these trends was instigated by the new nationalistic ideologies stemming from the foundation of the Czechoslovak Republic in 1918.

Kroha's interiors, together with his projects for new churches, sculptures and theatrical scenery, embodied the plastic and dynamic qualities of entire forms truly following the pattern of Cubist theories. He tried to create totally three-dimensional Cubist compositions by transforming the exterior into the interior and by bringing the cut, slanting, broken forms inside the building. This was further underlined with sculptures, paintings and furniture.

These works later helped him to go over to the Rationalistic style of clean cubic forms of harmonic composition which neared the style of the Purists— Le Corbusier and Ozenfant—and the styles of Neoplasticists and Constructivists.

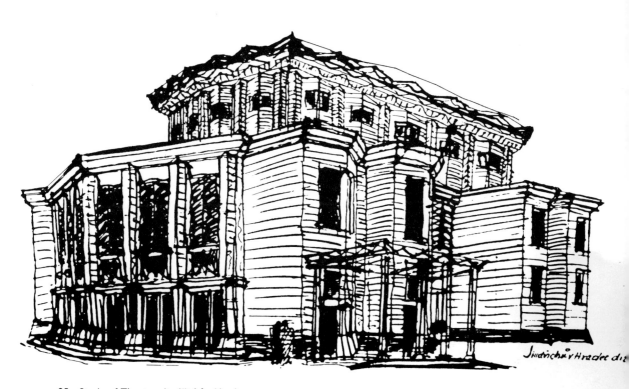

25 Study of Theatre, Jindřichův Hradec,
 J. Gočár, 1911-12

53

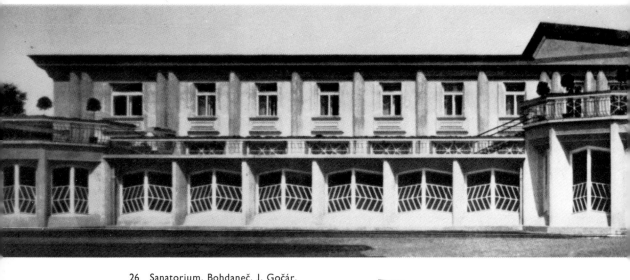

26 Sanatorium, Bohdaneč, J. Gočár,
1911-12

27 Sanatorium, Bohdaneč, part of façade,
J. Gočár, 1911-12

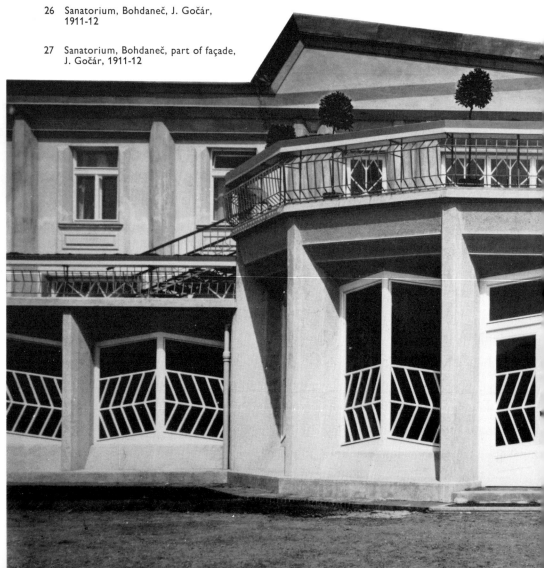

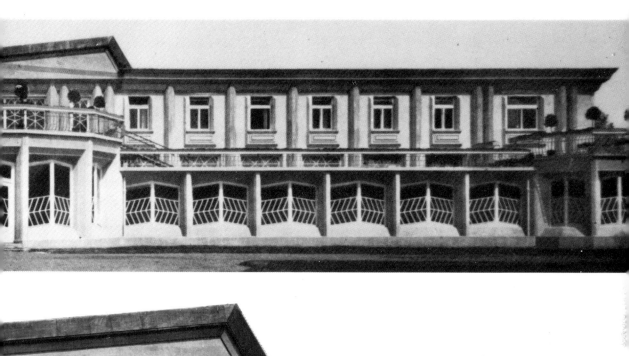

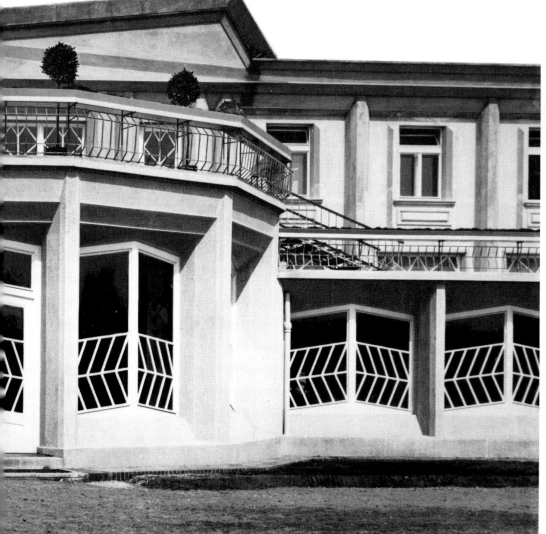

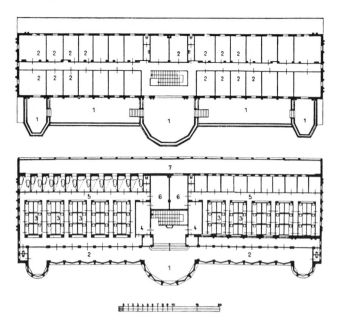

28 Sanatorium, Bohdaneč, J. Gočár,
1911-12, Ground Floor: 1 Hall, 2
Colonnade, 3 Rest Rooms, 5 Corridors,
6 Massage, 7 Peat Baths; First Floor: 1
Balcony, 2 Bedrooms

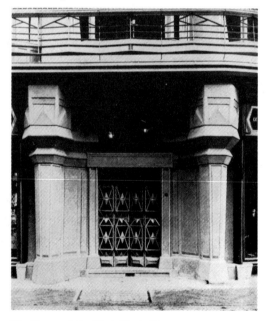

29 House of the Black Virgin Mary,
Prague, entrance, J. Gočár, 1911-12

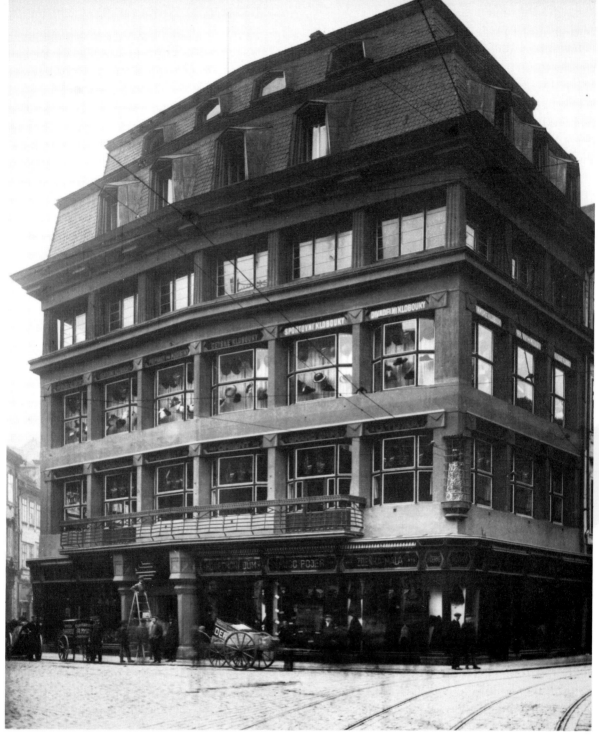

30 House of the Black Virgin Mary,
Prague, J. Gočár, 1911-12

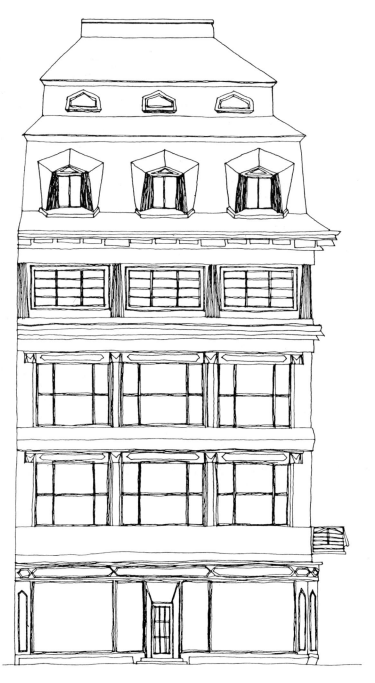

31 House of the Black Virgin Mary,
Prague, side elevation, J. Gočár,
1911-12

58

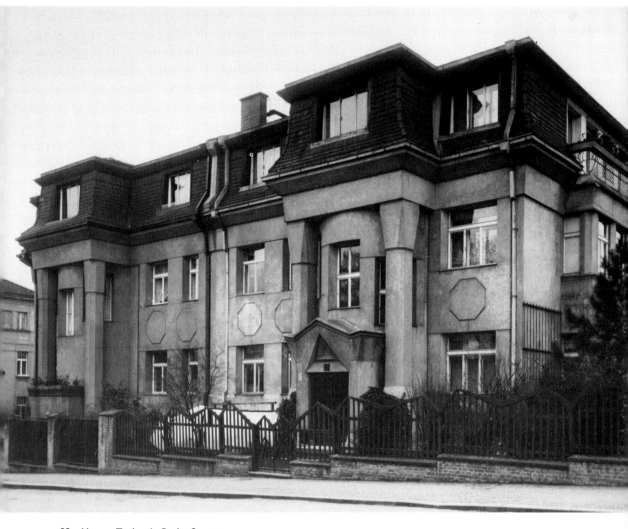

32 House, Tycho de Brahe Street,
 Prague, J. Gočár, 1911-12

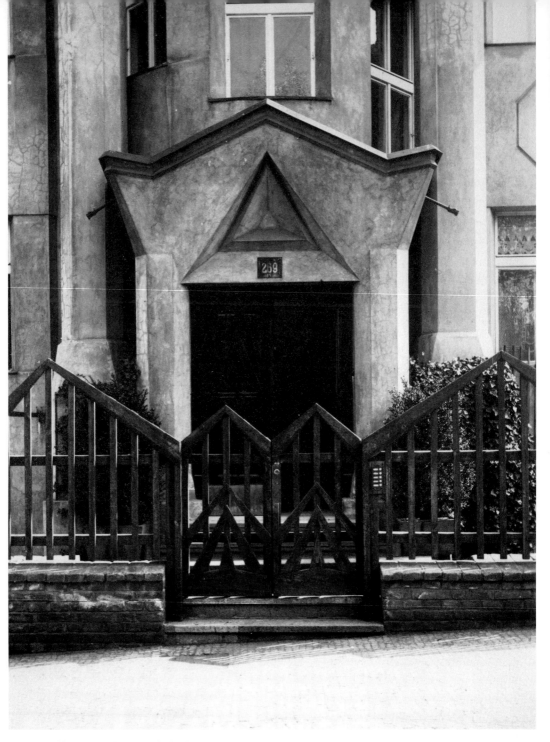

33 House, Tycho de Brahe Street, Prague,
 entrance, J. Gočár, 1911-12

60

34 Design for reconstruction of the Town
 Hall, Havlíčkův Brod, P. Janák,
 1912-13

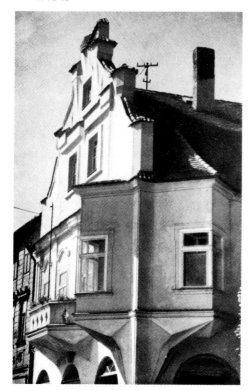

35 Reconstruction of House No. 13,
 Pelhřimov, P. Janák, 1913

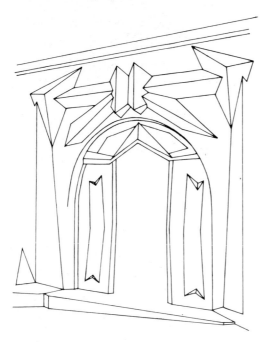

36 Reconstruction of House No 13,
 Pelhřimov, entrance, P. Janák, 1913

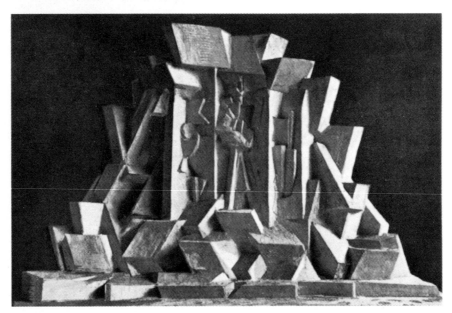

37 Model of competition design for the
 Žižka Monument, Prague, P. Janák &
 O. Gutfreund, 1913

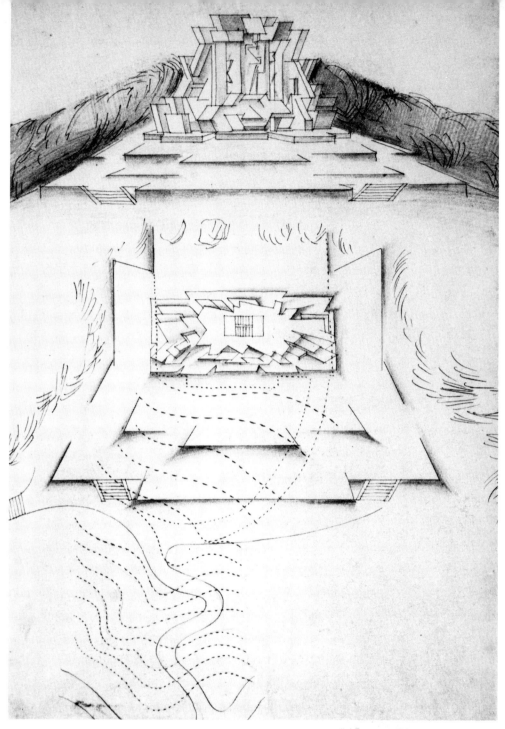

38 Plan and elevation of competition
 design for the Žižka Monument,
 Prague, P. Janák & O. Gutfreund, 1913

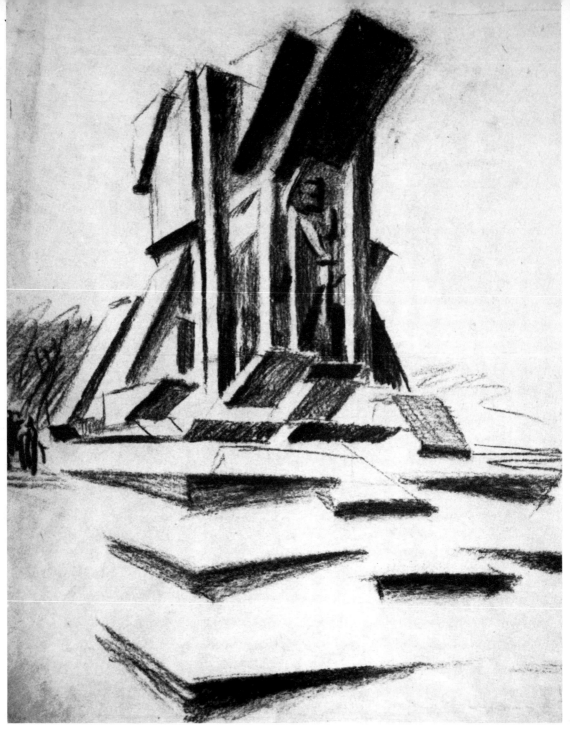

39 Competition design for the Žižka
Monument, Prague, perspective sketch
P. Janák & O. Gutfreund, 1913

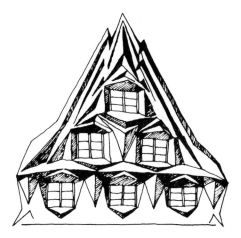

40 Design of a Gable House, P. Janák, 1912

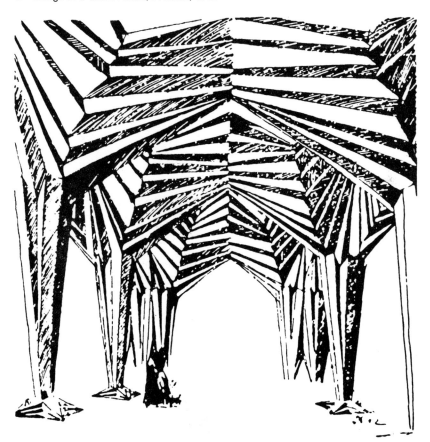

41 Interior design, P. Janák, 1912

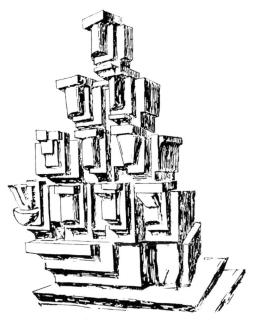

42 Design of a Monument, P. Janák, 1913

43 Villa, Vyšehrad, J. Chochol, 1913

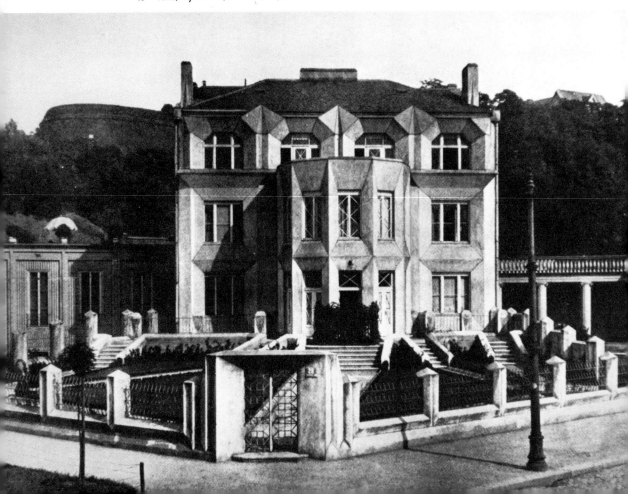

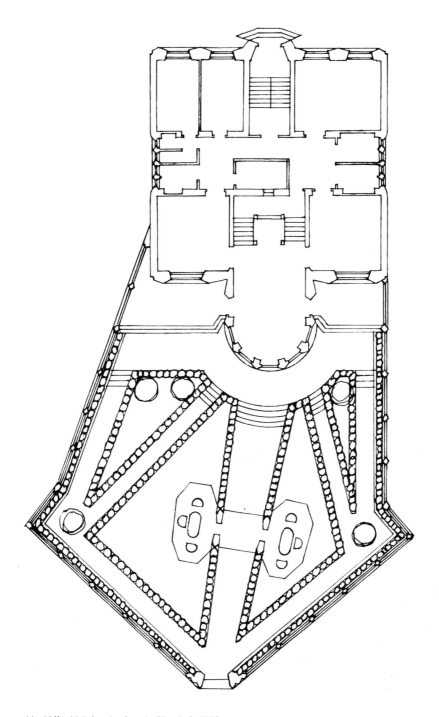

44 Villa, Vyšehrad, plan, J. Chochol, 1913

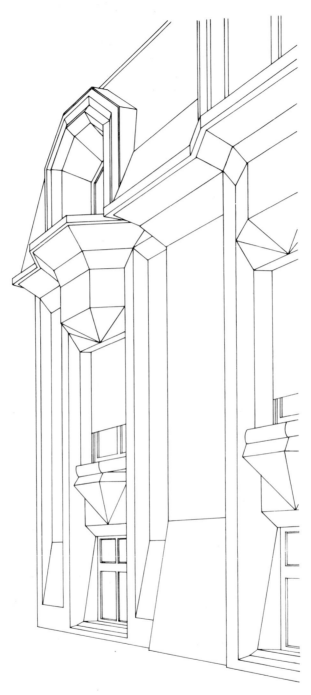

45 Apartment Block, Vyšehrad, part of
 façade, J. Chochol, 1913

68

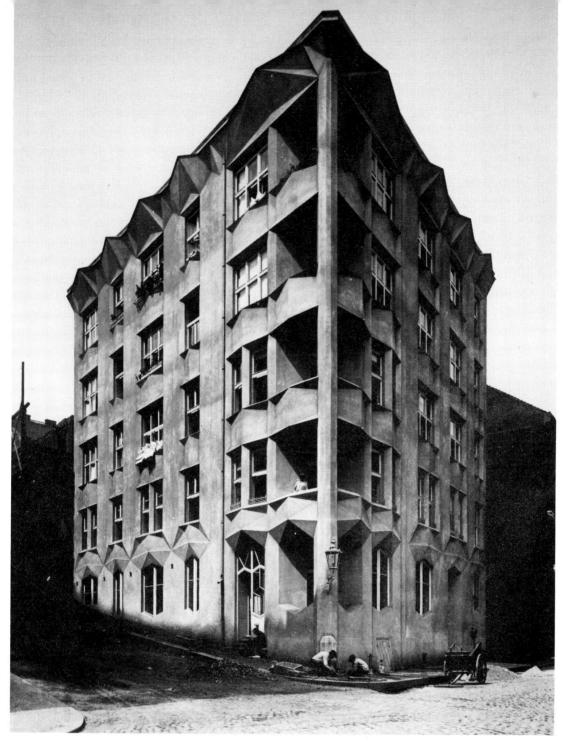

46 Apartment Block, Neklanova Street,
Vyšehrad, J. Chochol, 1913

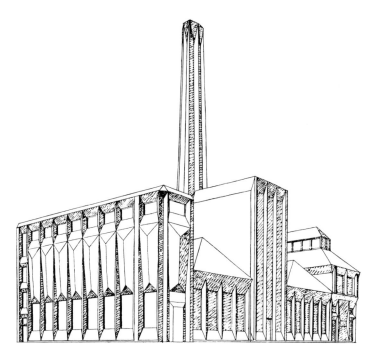

47 Study of a Factory, J. Chochol, 1912

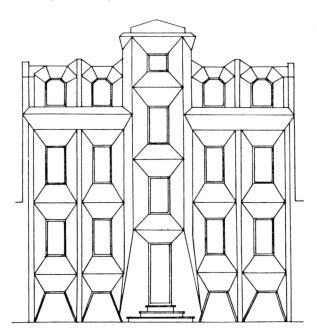

48 Façade design, J. Chochol, 1913

70

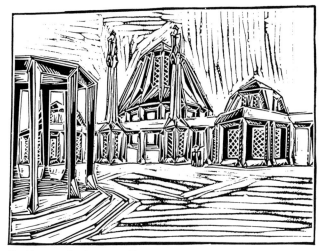

49 Design of a Cemetery Entrance,
V. Hofman, 1912, linocut

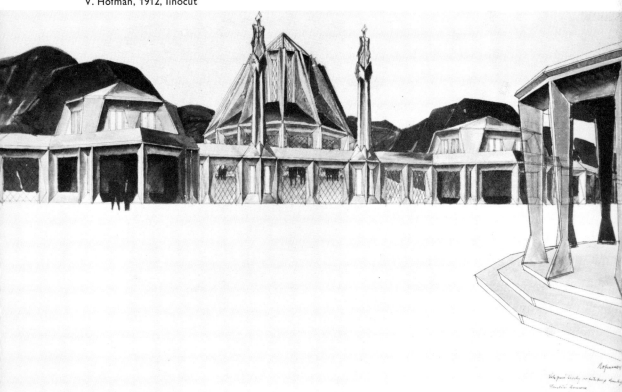

50 Design of a Cemetery Entrance,
V. Hofman, 1912

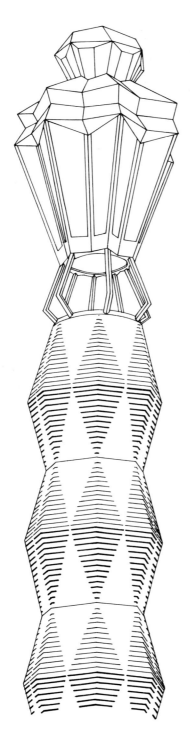

51 Lamp Post, Jungmann Square, Prague,
V. Hofman, 1913

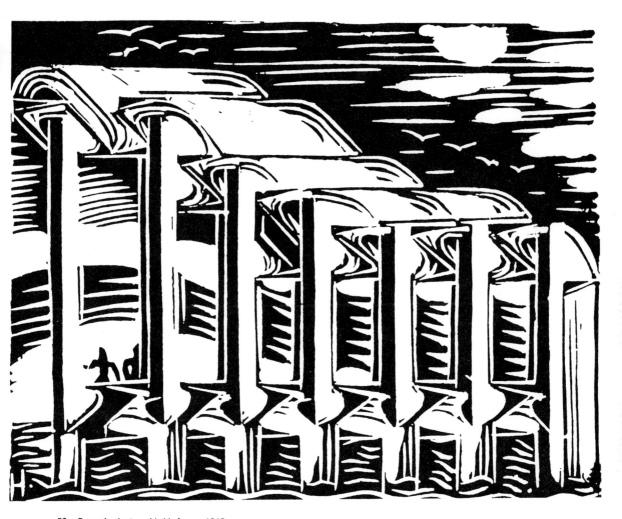

52 Pergola design, V. Hofman, 1913,
 linocut

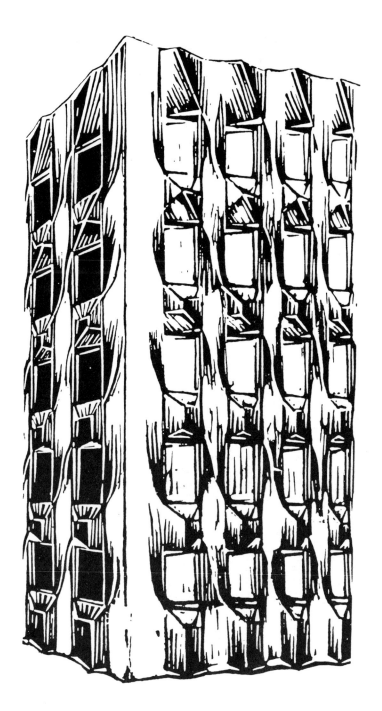

53 Study of a Residential Building,
 V. Hofman, 1914, linocut

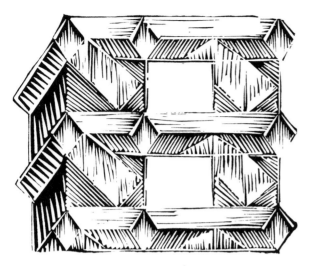

54 Facade detail, V. Hofman, 1914, linocut
 (published in **Der Sturm** V, no 6,
 1914-15)

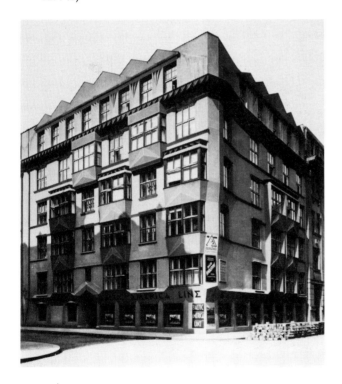

55 Apartment Block, Prague, O. Novotný,
 1917

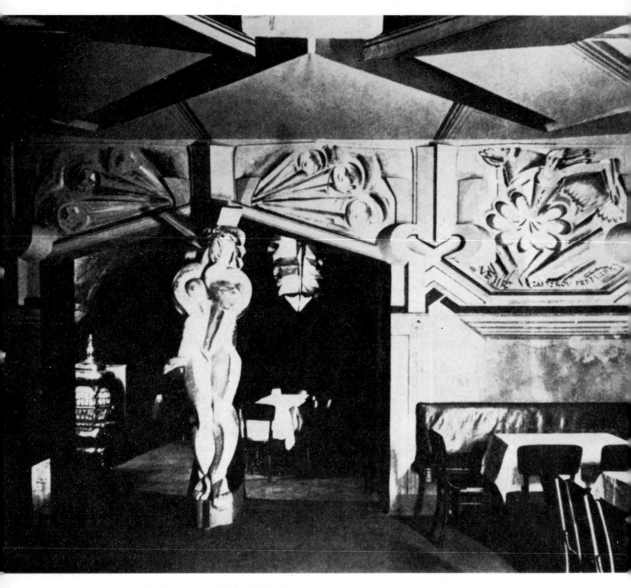

56 Montmartre Night Club, Prague,
J. Kroha, 1918

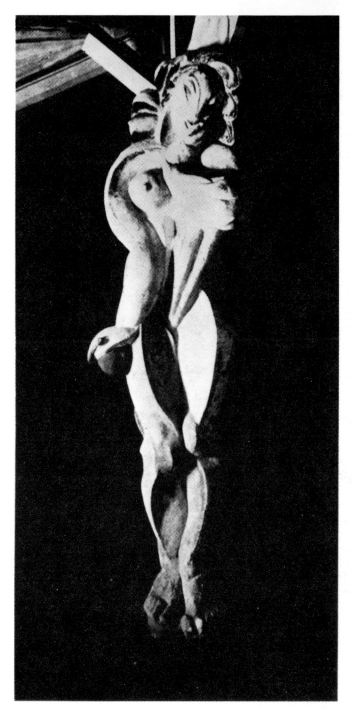

57 Montmartre Night Club, Prague,
 Crying Eva, J. Kroha, 1918, plaster,
 3500mm high

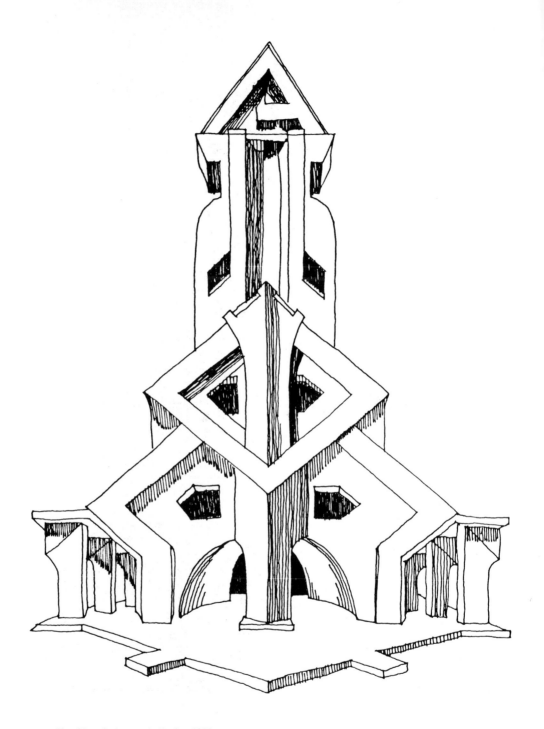

58 Church design, J. Kroha, 1919

78

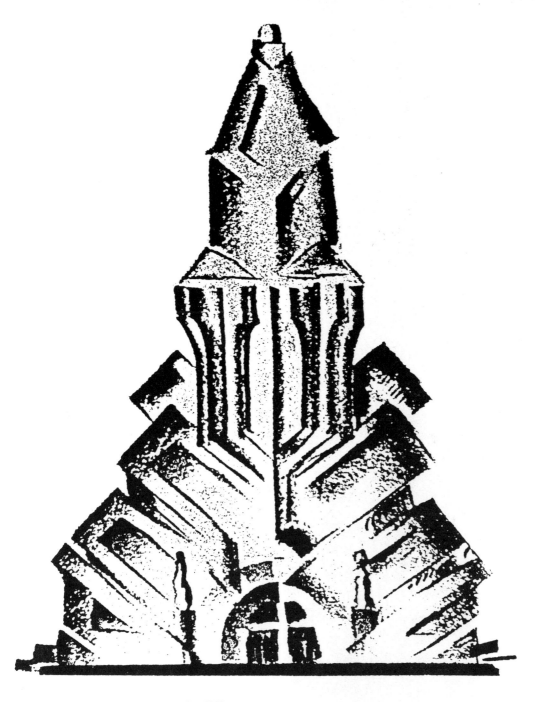

59 Study of a Church, J. Kroha, 1919,
charcoal

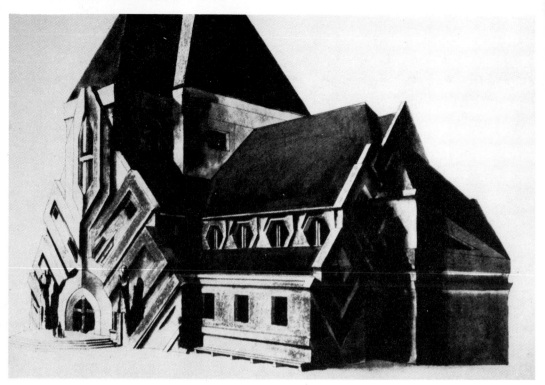

60 Design of a Roman Catholic Church,
 J. Kroha, 1919
61 Interior Study of a Crematorium,
 Pardubice, J. Kroha, 1920

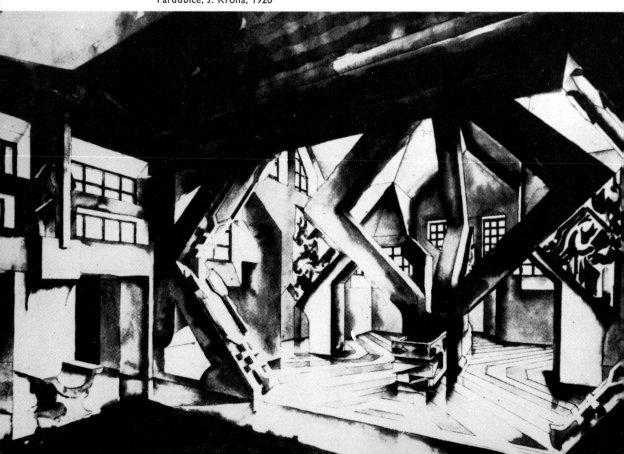

Cubism in the Applied Arts

In 1912 Gočár together with Janák and F. Kysela founded the *Pražské umělecké dílny* (Prague Artistic Workshops). This enterprise was concerned with interior projects and furniture manufacture after the example of *Wiener-Werkstätte*. Their aim was to bring new concepts into the decorative crafts industry in opposition to the still surviving Arts and Crafts movement of William Morris, and Art Nouveau.

There were three phases in the development of Czech Cubist furniture design. In the first phase (1910-11) the architects worked under the influence of Analytical Cubism. They designed objects with oblique planes, bevelled edges, concave angles, broken and rugged surfaces, bent twisted legs, and with an emphasis on black and dark brown colours.

The second phase (1912-13) considered furniture more as pieces of sculpture, or as an architectural project resulting in a truly artistic object rather than a usable thing. 'Some pieces of furniture were too architectural at the beginning, almost loaded with movement, uncompromisingly plastic; therefore the independent life of the objects nearly oppressed the personal existence of the person living in such an interior.'[1]

To the third period belong several realized suites for individual interiors, which encompass the previous phases. There was a greater effort to achieve a balance between planes and plasticity leading to a new and subtle harmony.

In the design of furniture the architects were concerned mainly with form; in everything else they remained traditionalists. This is shown both in the types of furniture they designed, which were purposely derived from past periods, and in the layout of the interiors. They did not develop any integrated theory of of interior design and as they kept to the past furniture types no changes in layout or spatial arrangements were required.

Cubist architects did not regard a new conception of interior design as an issue and were content with a formal transformation of furniture and an elimination of the decorative elements of the past. The architects designed the furniture purely as dramatized, dynamic artistic shapes, searching in this way for new solutions to the problem of form.

The furniture was dissected into its component elements which were then placed together in new ways. The mass of a piece was broken into a system of several surfaces and planes, visibly separated but merged together in its totality, as in a Cubist painting. This was also what they tried to achieve in their architectural projects. 'The objects are broken up, plastically and spatially, into new component parts and the elements thus produced are recomposed into autonomous artistic composition.'[2]

If furniture was treated almost as pieces of sculpture, there were obviously less restrictions applicable than in building design. Here Cubist principles could be realized more freely than anywhere else within the world of architecture.

They 'ventured to the very boundaries of the static; in small articles, vases and the like, they shifted the centre of gravity and the equilibrium bent the surface into sharp profiles and cut it with deep incisions'.[3] The pieces of furniture designed for Gočár's own house demonstrate this. Cut prismatic surfaces and forms break the mass of the object into a work of art which is just about usable. The furniture was exciting and dynamic but the Cubist forms were carried to such an extreme that there seemed to be no further development possible within the given rules. After seeing a few photographs Apollinaire stated, in an article published in 1912[4], that he found this Cubist furniture to be not uninteresting.

The dynamic forms of Cubist furniture were designed with little consideration for constructional requirements and consequently the makers found it difficult to put the objects together satisfactorily. The problem of containment in the furniture design is even more enhanced than in the construction of buildings, as the architects were well aware; the furniture form has to be hollow in the case of wardrobes, sideboards, etc, with a thinner skin than house walls, and therefore, in practice the solution to the problem of supports, the connections of various members and surface planes was very difficult.

Especially problematical was the construction of junctions of the diagonal planes. It was found necessary to strengthen these connections by metal plates and ties to prevent cracking at a later date. Similar difficulties were experienced with upholstery where the designers ignored the special requirements which the fabric demanded when sharp angles and convex and concave planes had to be covered.

In addition to architecture and furniture design the architects were involved in the design of minor interior articles made mostly of ceramics, and to a lesser extent, of metal and glass. These works were designed for the Artěl Cooperative, which distributed them to a wide circle of customers in an effort to introduce new, modern and inexpensive forms into general use, thus fulfilling the architects' wish to involve art in everyday life.

These objects demonstrated the dynamic relationship between volume and the surface with its live rhythms of decoration. Both these objects and the design for furniture clearly foreshadowed asymmetrical compositions of geometrical forms in the applied art of the 1920s and '30s. This design work, of small interior articles and furniture, was used by the architects as a testing ground to verify their theories in practice.

Formerly art was used to create a cushion, a jewel, and so on. Now creative art expresses itself in the conception of a teapot, a tray, etc. It is important that art should consciously move towards the form itself in order that new ideas about forms and the relationships between them can be discovered,

and so that the value and regularity of the form can be ascertained by trying out variations of it in differing environments; realizing a particular form in one material is not enough: the form—the substance of stylistic composition must be reduced to its essentials, to an abstraction which is then valid in all materials (timber, glass, stone, and so on) having the ability means of its shape, to overcome all these substances.
ın this way creative activity in the applied arts is helping to resolve architectural problems: it works over and supplements the experiences gained in architecture; architecture expresses plastically certain large wholes and complicated intersections of energies, while a candlestick, a bowl, or a teapot provide opportunities for resolving, on a small scale, similar problems taking into account shape, size, etc which make it possible to realize our Cubist opinion concerning mass and its volume.[5]

The truly Cubist works ended with the approach of World War I. The movement was a short one. The immediate impact of this particular powerful style of painting and the eagerness to become involved had lasted just long enough to allow architects to get through all the basic motions and scales of application.

The further development of Cubism was curtailed by World War I after it became apparent that the style was unable to cope with the design of internal volumes which had never really followed the exuberance of the exteriors. The progress also diminished due to the lack of support and following from abroad.

The impulses generated by Cubist paintings were clearly the decisive modes of expression and were, for this generation, the most acceptable inspiration for their designs.

The breakdown of mass into independent formal elements, as was shown in paintings and sculptures, was impossible in architecture or applied art. Nevertheless the architects' stereo-plastic understanding of form corresponded to the principle of the reduction of material volume to a distorted plane, thus creating the distinct diagonal motif. Their theories emphasized artistic form above all else and both technical and functional considerations were relegated to second place. They stressed the priority of form over function hoping that the contemporary technical progress would bring improvement in the technological possibilities of building construction. The relaxation of dependent relationships between form and function led to freedom from the conceptions of the past.

The need for a basically utilitarian functionalism has been technically achieved to such an extent that now, through form, the original function and ultimately, the need itself could be revised in retrospect. The creativity of Cubist architects tended towards antifunctionalism which together with the dynamics of spatial perception determined their method of work. Their achievement was founded on

their spiritualized conception of motion as something proceeding from the internal structure of the matter itself. The style imposed visual effects directly, exploiting an urgent confrontation of matter, motion, gravity, time and space, leading to the four-dimensional conception of art.

Because of their kinesthetic sensitivity architects reacted actively to the formal impulses of Cubist paintings as well as to the newly discovered relationship between matter and space. 'The architects put the idea of form, with given motion against structural, functional and material concepts. The architect has penetrated the form now. In the past he stopped at its boundary, by its surface.'[6] They managed to bring the concepts of Cubism a step further, even beyond the achievement of the painters, by tackling the form within the truly many sided, four-dimensional space.

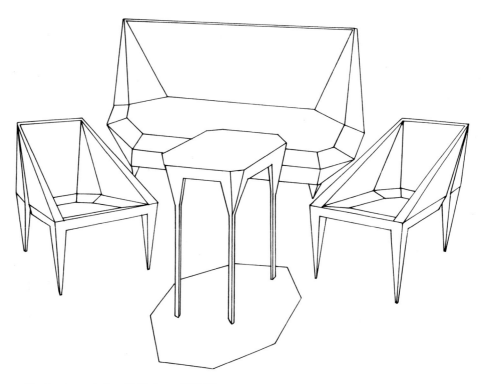

62 Furniture design, V. Hofman, 1911-12

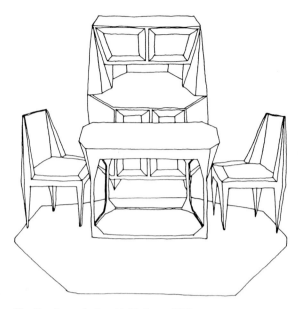

63 Furniture design, V. Hofman, 1912

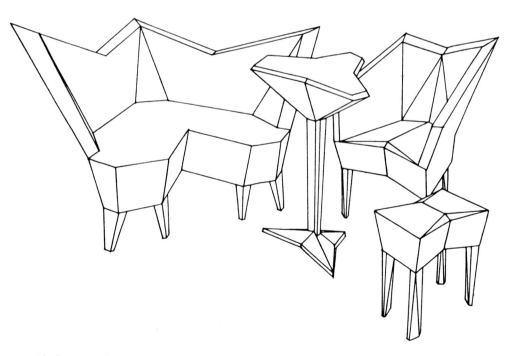

64 Furniture design, P. Janák, 1913

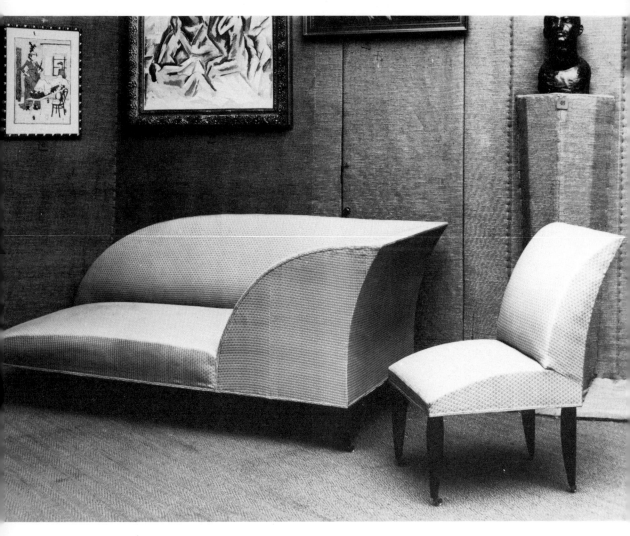

65 Sofa and Chair, V. Hofman, 1911, as
shown at the Third Exhibition of the
Skupina výtvarných umělců,
Municipal House, Prague, May-June
1913

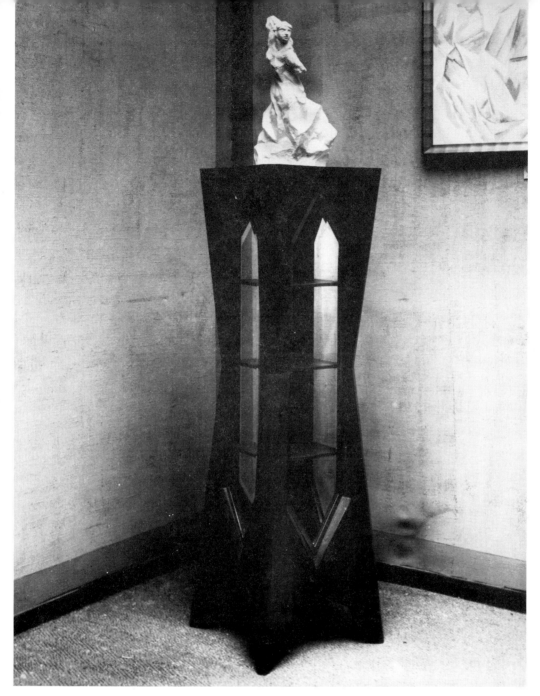

66 **During the Toilet,** O. Gutfreund,
1910-11 on the Glazed Stand by
V. Hofman as shown at the Third
Exhibition of the **Skupina výtvarných
umělců,** Municipal House, Prague,
May-June 1913

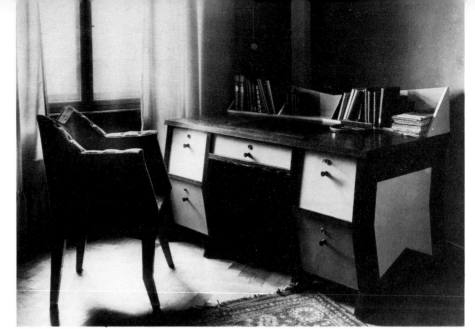

67 Writing Desk and Armchair for Dr
 J. Borovička, P. Janák, 1911-12, desk:
 dark stained polished oak with white
 infill panels, veneered, mahogony
 internally, 780 x 1600 x 780mm;
 armchair: softwood frame, painted
 white, upholstery in grey-green fabric
 with flower pattern, 940 x 620 x
 550mm, manufactured by **Pražské
 umělecké dílny (PUD),** now in
 Museum of Decorative Arts, Prague

68 Bookcase for Dr J. Borovička, P.
 Janák, 1911-12, softwood, painted
 white, black paint internally, 1555 x
 2240 x 450mm, manufactured by **PUD,**
 now in Museum of Decorative Arts,
 Prague

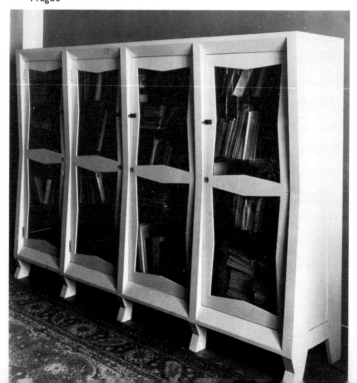

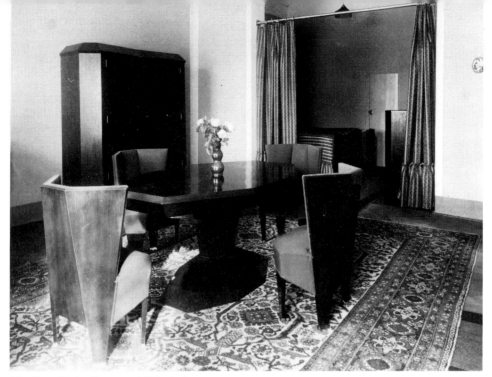

69 Own Dining Room with Wardrobe,
 J. Gočár, 1912-13

70 Sideboard, J. Gočár, 1913, oak veneer
 stained red-brown, mahogony
 internally, 2000 x 1480 x 580mm,
 manufactured by **PUD,** Museum of
 Decorative Arts, Prague

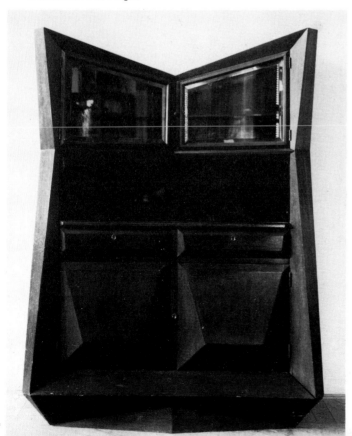

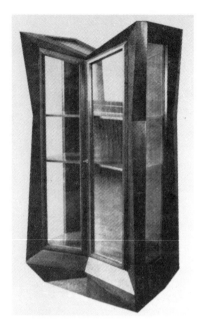

71 Glass Cupboard, J. Gočár, 1913, oak
 veneer stained red-brown, mahagony
 internally, 1930 x 1100 x 600mm,
 manufactured by **PUD,** Museum of
 Decorative Arts, Prague

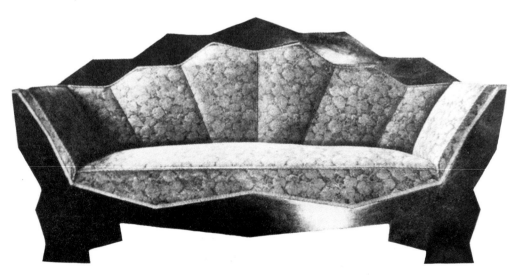

72 Sofa, J. Gočár, 1913, oak veneer stained
 black, upholstery in grey, white and
 green, 1185 x 2300 x 750mm,
 manufactured by **PUD,** Museum of
 Decorative Arts, Prague

90

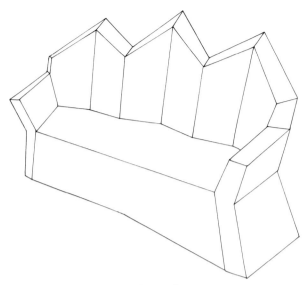

73 Sofa, J. Gočár, 1913, softwood frame,
upholstery with flower and leaf motifs
in black and grey-purple, 1240 x
2320 x 550mm. manufactured by
PUD, Museum of Decorative Arts,
Prague

74 Sideboard, O. Novotný, 1922, oak
veneer stained black, 1770 x 1510 x
600mm, Museum of Decorative Arts,
Prague

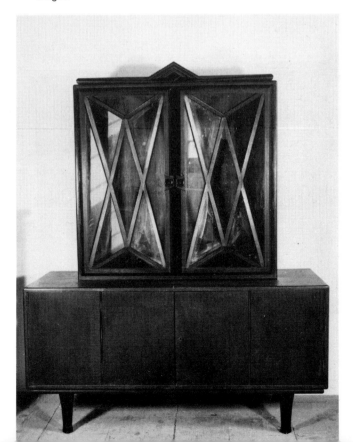

75 Wallpaper design, P. Janák, 1911

76 Wallpaper design, P. Janák, 1911

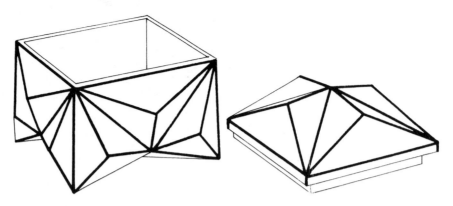

77 Ceramic Container, P. Janák, 1911,
Artěl, earthenware, ivory glaze,
decorations in black, 90mm high,
Museum of Decorative Arts, Prague

78 Ceramic Containers, P. Janák, 1911,
Artěl, earthenware, white glaze,
decorations in black, brown, blue and
gold, 80 and 120mm high, Museum of
Decorative Arts, Prague

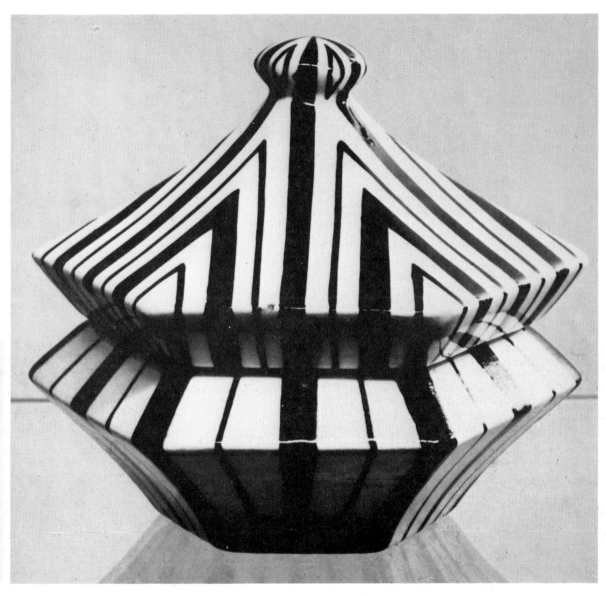

79 Ceramic Container, P. Janák, 1911,
 Artěl, earthenware, white glaze, black
 decorations, 80mm high, Museum of
 Decorative Arts, Prague

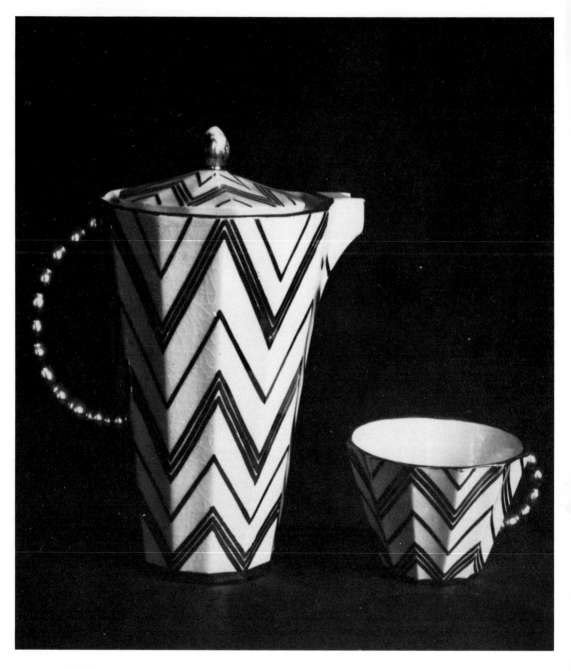

80 Part of Coffee Set, P. Janák, 1911,
Artěl, earthenware, white glaze, gold
decorations, 220 and 65mm high,
Museum of Decorative Arts, Prague

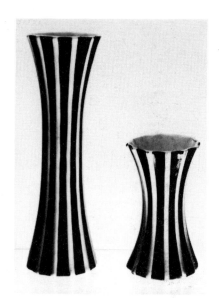

81 Vases, P. Janák, 1911, **Artěl**,
earthenware, black glaze, white
decorations, 238 and 135mm high,
Museum of Decorative Arts, Prague

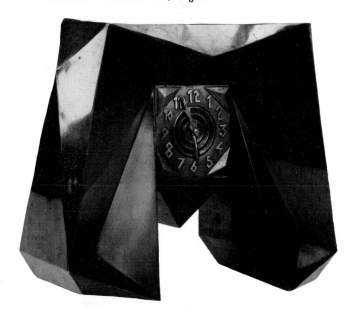

82 Clock, J. Gočár, 1913, tempered brass,
240 x 290 x 135mm, manufactured by
PUD, Museum of Decorative Arts,
Prague

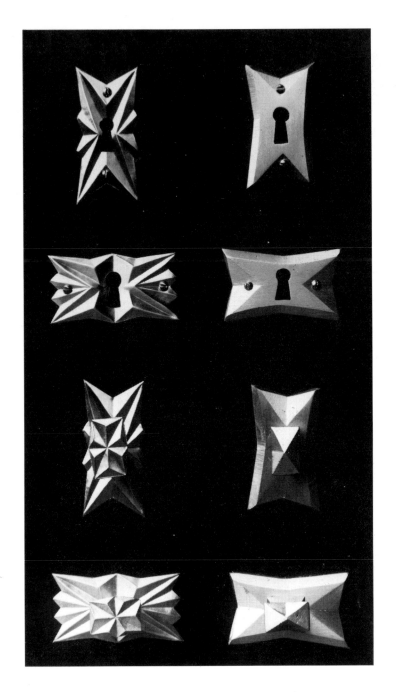

83 Key-hole Plates and Drawer Knobs,
 J. Gočár, 1913-14, cast brass,
 manufactured by **PUD**

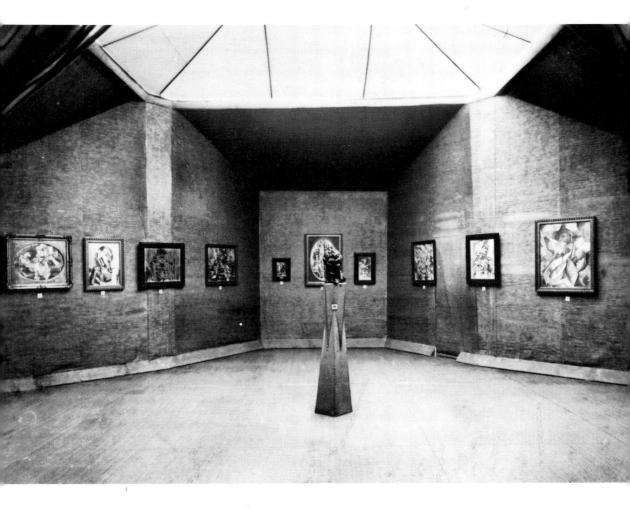

84 The Third Exhibition of the **Skupina**
výtvarných umělců, the Hall
containing the works by P. Picasso,
G. Braque, J. Gris and A. Derain,
(**Head of a Woman,** P. Picasso,
1909-10 on the centre stand),
Municipal House, Prague, May-
June 1913

Contemporary World Architecture

A brief reminder of events in architecture elsewhere during the period 1910-14 might bring into perspective the originality and singularity of architectural Cubism. During the years when Cubism was the style in Bohemia and France the rationalistic spirit of the Machine Age was gaining momentum in other parts of the world, over the Art Nouveau movement which was losing ground and had, by then, almost disappeared.

In Germany, under the influence of William Morris, the *Deutscher Werkbund* was founded in 1907. This was an association of artists, designers and craftsmen who arranged exhibitions of their works and studied the problems of applied design. It gave them an opportunity to get involved with new and growing industries and to directly apply the new ideas. Large German industrial companies were becoming interested in improving the design of their goods and tried to impress the public with their modern outlook. Soon after the establishment of *Deutscher Werkbund* Peter Behrens (1868-1938) was asked by the AEG of Berlin to design their new buildings, products, packaging, advertising and stationery material. His AEG Turbine Factory (1909) in Berlin is one of the first outstanding buildings of the modern Rationalistic movement. He made logical use of new materials such as steel and glass, which he formed into a monumental and at the same time geometrically simple mass.

Behrens's pupil Walter Gropius (1883-1974) designed the Fagus Works at Alfeld with Adolf Meyer in 1911-14 where he took even further the rationalism of the Turbine Factory with the use of a flat roof, curtain walling without corner mullions and the general disposition of the block. The same approach is expressed in the Model Factory and Office Block at the Cologne Werkbund Exhibition in 1914 which had an additional motif of two externally exposed staircases enclosed in curved glass.

In contrast H. Poelzig's and M. Berg's works from the years 1909 to 1913 showed the signs of plasticity and the treatment of forms, which initiated the evolution of Expressionist architecture after World War I. This type of architecture was inspired by Expressionist art and was underlined further by varying levels of influence stemming from Art Nouveau, Romantic Nationalism and Rationalism.

Rationalism also led the way in the works of architects who had settled in the Austrian part of the Austro-Hungarian Empire which also included the Czech lands. Notable among these architects were O. Wagner, J. Hoffmann, J. M. Olbrich and, especially, Adolf Loos.

A. Loos (1870-1933), after studying in the United States, settled in Vienna in 1897 and began to publish a series of articles in which he rejected the predominantly displeasing forms of applied art based on inspirations from Renaissance or Sezessionist motifs. He advocated a rebirth of simple, solid and honest

craftsmanship, and the disappearance of ornamentation from objects and tools in daily use. Loos arrived at the conclusion that architecture has nothing to do with decorative art and included the building industry in the sphere of crafts. Loos's theories and buildings had a far-reaching effect on the future course of architecture.

In 1909, F. T. Marinetti founded the Futuristic movement in Italy. It was the rapid arrival of a technological society full of motor cars and railways which sparked off the theories expressed in their manifestoes. The writings of Marinetti and Boccioni praised speed, danger, energy, and war as the cleansers of society, and called for the annihilation of space and time.

Futurism was initially derived from Cubist principles but made its own independent way. It was mainly concerned with the dynamic motion of bodies and the representation of that motion which they adopted from the Cubists. They extended these representations to the advantage of their own work and turned their interest towards a machinery and technology orientated world.

From 1912 to 1914 A. Sant 'Elia (1880-1916), the most celebrated Futurist architect, made a number of inspired sketches of buildings and proposals for town planning, which showed some very far-sighted designs, including motorways, airports and big electricity generating stations. Futurism was short-lived but greatly influential, mainly through the theoretical writings which encouraged the development of modern architecture all over the Continent.

In the Netherlands H. P. Berlage (1856-1934) helped to bring back architecture based on the traditions of the Arts and Crafts movement. Berlage was the main personality promoting the rational approach. His articles and lectures propounded the importance of reason and logic in the use of materials and in the consideration of structural design. Berlage's architectural medium was the use of brickwork with a change, later, to concrete.

Reacting, as did Czech Cubists, to the Rationalism of Berlage M. de Klerk, with P. L. Kramer and M. van der Mey, developed a new romantic trend stressing individual artistic design and fussy detailing but ignoring the economic cost of construction and the proper use of materials. The final break with Traditionalism was established only after 1917 by the Neoplasticism of de Stijl.

Apart from the influence, at the beginning of the century, of W. Morris, C. F. A. Voysey, C. R. Mackintosh and A. H. Mackmurdo British architects did not play an active part in the development of modern architecture until after 1930. The British contribution in the period before World War I was in the foundation of the first independent garden city, Letchworth, designed by B. Parker and R. Unwin in 1904, and, the foundation of Hampstead Garden Suburb, designed by the same planners, in 1907.

In the United States during the years 1910-14 F. L. Wright (1867-1959) and the

Greene brothers, along with L. Sullivan in his later works, founded the base for the future progress of modern architecture. Chiefly it was Wright who revolutionized the profession with his design concepts in Robie House in Chicago (1909) and Gale's House in Oak Park (1909) in the layouts of which he put into practice the new principles of free spatial flows. These spaces were externally enclosed with long, horizontal, pitched roofs, overhanging eaves and were surrounded with square, right-angle walls and continuous window bands, with almost no ornamentation. The cubic forms, their spatial interaction, and the use of expressive new materials appealed to foreign architects and influenced the progress of the rational modern style.

After Cubism

In Czechoslovakia after World War I a National Decorative style and Rondo–Cubism, which was a rather free modification of Cubism, briefly appeared. The new aims of the post-war period were the modernization of industry and the economy, the repair of war damage and the building up of the strength of the new republic. The young spirit of the generation coming back to the interrupted work was inspired by nationalistic feelings which were generated by the changed circumstances of the political environment.

Gočár after his involvement in furniture design and a few small projects was commissioned to design a building for the Czechoslovak Legiobank (Plates 85 & 86) where his sensitive handling of circular and cylindrical forms, already tried in some works before the war, was realized. Additionally for the first time he deliberately used few basic colours and their interactions in simple compositions. The plastic or mostly flat ornamental motifs had very strong folklore connotations. In the Legiobank, the best work in Rondo–Cubism, the plasticity and monumentality of the façade showed Gočár's talent of handling single elements which would merge into a complicated and unified whole taking good advantage of the massive stone material and sculptures to underline the composition. In the interior, mainly in the banking hall, the theme of circle and curve was used throughout with a simple two- or three-tone colour scheme.

Janák at the same time was still concentrating on the Cubist basis of plasticism and slowly transforming these forms towards a style similar to the Neoplasticism of the Dutch de Stijl. Plasticity and massive forms were taking over the dynamic qualities in their entirety as well as in the details. The pyramids and slanting surfaces turned into cubes, and right-angled corners and edges still retained the singular colour and the use of smooth rendering as an external finish. This change was briefly interrupted by the new Decorative style which diverted Janák's development to Purism.

From this period the most noteworthy building projected by Janák was the Riunione Adriatica di Sicurta in Prague (Plate 87) in 1923-5. It is remembered for its Renaissance expression but was undertaken without the use of historical details. The strong plasticity of the façade with its heavy cornices shading the window openings almost appeared to be on the borderline of practical realization.

After these diversions the young generation of architects returned, in 1922, to the rationalistic tendencies set in motion by Kotěra in the first decade of the twentieth century. The architecture attempted during this period reached a magnificence comparable to the buildings put up at the same time by Le Corbusier, J. J. Oud, W. Gropius, T. van Doesburg, Mart Stam, A. Loos and others.

After World War I the genius of Le Corbusier dominated the development of modern architecture in France. In 1918 in Paris C. E. Jeanneret (Le Corbusier)

together with A. Ozenfant published a Purist Manifesto *Aprés le Cubisme*, which was a catalogue to their first exhibition. They proclaimed that after Cubism there was to be Purism. They insisted on economy and efficiency, on the separation of techniques and aesthetics, on the dominance of simple geometry, and on art being assessed by the degree to which it was compatible with the right-angle and the cubic characteristics of the present time. The work of art must not be accidental, exceptional, impressionistic, inorganic, protestatory, or picturesque but on the contrary, generalized and static, expressive of the invariable. They stressed that Purism was a reaction against the Cubists' 'lyrical' attitude which affected their work causing it to become too disorderly and too personal.

These philosophical and aesthetic arguments together with other important interchanges of ideas appeared in such journals as *L'Espirit Nouveau*, *Les Cahiers de l'Effort Moderne* and *L' Architecture Vivante*. In addition to these theoretical discussions, the Dutch de Stijl, already founded in 1917, and the work produced by the German Bauhaus further influenced the progress of the modern architectural movement in France.

Le Corbusier, starting with his *Maison Citrohan* (1920), *Immeubles-Villas* (1922) and his book *Vers une architecture* (1923), together with P. Jeanneret, A. Lurcat, R. Mallet-Stevens, G. Guevrekian, J. Badovici and others, established the International style which has survived as an architectural trend, with various modifications, until the present day.

85 Legiobank, Prague, J. Gočár, 1922-3,
sculptures by O. Gutfreund &
J. Štursa

105

86 Legiobank, Prague, main hall,
 J. Gočár, 1922-3

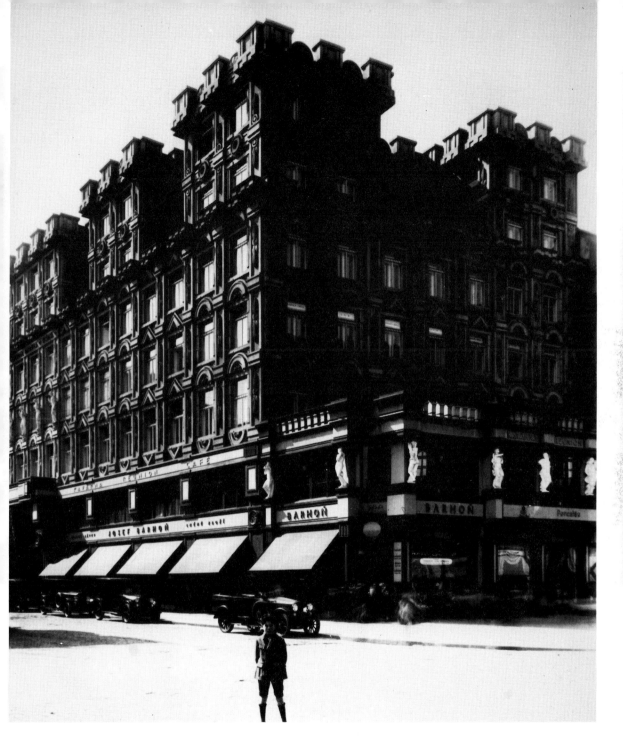

87 Riunione Adriatica Sicurta, Prague,
P. Janák & J. Zasche, 1923-5

107

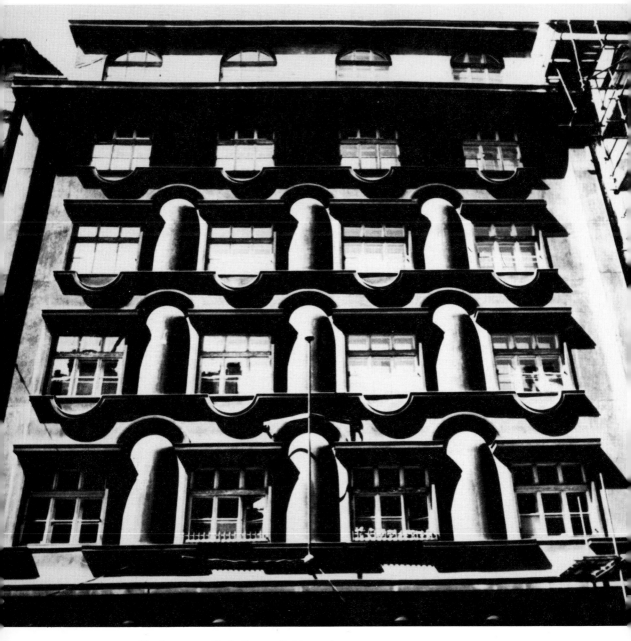

88 Apartment Block, Prague, O. Novotný,
 1922-3

The Influence of Architectural Cubism

The Cubist trend in architecture which appeared so strongly and in such isolation in Bohemia, apart from the brief involvement of R. Duchamp-Villon, is not recorded fully anywhere in western architectural studies. It seems rather incredible that the buildings which were born in the style which started off the whole modern movement have been entirely missing from all the truly historical accounts. The merit of the buildings and projects mentioned above based on thoroughly worked out and sound theories, can, even today, set an example of an approach to architectural creativity. Although the theories behind them are often vague in formulation, they are unique for their content and for the early realization of future architectural problems.

It is evident that although Cubism stayed basically within the old framework of tendencies already established from the previous styles, it nevertheless overcame, with its plastic and dynamic concepts, the inherited forms and prepared the ground for the triumph of truly modern architecture. In fact the Cubist trend stimulated further development.

The Czech style, it can be claimed, played an influential role in the early formative years of the German and Dutch Expressionists, W. Gropius, E. Mendelsohn, M. and B. Taut, H. T. Wijdeveld, W. A. Hablik and others. In this way it helped to lay the foundations of Expressionism, the Neoplastic style of de Stijl and Constructivism, especially in its advocacy of the use of spotless, colourless surface treatment for exterior materials in combination with dramatic, dynamic moving sharp prismatic forms.

It is clear that both W. Gropius's Memorial (Plates 89 & 90) to the March Victims in Weimar (1920-21) and M. Taut's Wissinger family tomb in Stahnsdorf cemetry near Berlin (1920) are Cubist in their concept and realization.

Further comparison can be made with the radiant prismatic elements of the decorative style used in the architecture of the Firestone Factory in 1928 and the Hoover Factory in 1932 (Plate 91) near London, both by Wallis, Gilbert & Partners, the Chrysler Building (W. Van Alen, 1928) in New York and other similar buildings which appeared almost twenty years after the Cubist architectural trend.

Czech Cubist furniture was exhibited at the Werkbund exhibition in Cologne in 1914 in the Bohemian Section of the Austrian pavilion, where it did not go unnoticed. Peter Jessen's description stated that the objects shown sought 'beauty in planes and solids by means of sharp-edged contours and daring angles, by renouncing everything irrational . . . the tectonic Cubism was born here more from the reason rather than feeling . . . but only the future will show if the full-blooded genius of this new movement will continue to develop further'.[1] In fact, as in architecture, Czech Cubist furniture design did, by its novel formal character, anticipate the design tastes which developed in the applied arts during

the 1920s and '30s—for an example, see J. Gočár's sofa (Plate 72).

Le Corbusier and Ozenfant stated that without Cubism there would not be anything created today, in the sphere of arts, of any importance. The style cleared the way as it succeeded to clarify the form and bring forward the importance of spatial awareness. Cubism was the point of departure for all constructive and elemental art.

S. Giedion, for example, calls attention to the effect of Cubism upon architecture in two buildings constructed after World War I. He describes W. Gropius's Bauhaus at Dessau of 1926 (Plate 92) as 'the hovering, vertical grouping of planes which satisfies our feeling for a relational space, and there is the extensive transparency that permits interior and exterior to be seen simultaneously, *en face* and *en profile*, like Picasso's *L'Arlésienne* of 1911-12 . . .' (Plate 13).[2] Giedion says further that 'It is impossible to comprehend the Villa Savoye [at Poissy, 1928-30 by Le Corbusier (Plate 93)] by a view from a single point; quite literally, it is a construction in space-time.'[3]

The influence of Cubism here is in the representation and vision of space and in spatial exploration. The architects' creative thinking was guided in terms of volumes, advancing and receding planes, surfaces intersecting and penetrating each other, and a superimposing of planes which were thus presented simultaneously, with inner and outer spaces woven into each other.

But the Cubist influence in the 1920s was different from that which was immediate and spontaneous in Bohemia and France before World War I. That architectural creativity adopted the full composition and structure and theory of Cubist painting rather than just applying the distant, cool and analysed principles of an, at that time, already dead Cubist style.

The true Cubist movement was highly romantic and idealistic, and rather experimental. The principles of the rationalistic approach, based on the creation of spaces for people to live or work in with a certain amount of economic restraint, have been neglected for the sake of young enthusiasm in order to try out something new and exciting. There is no regret in seeing the results.

It seems surprising that architects have fallen so strongly under the influence of painters and sculptors professing the Cubist style. After all Cubist paintings were not intended, and not created, to influence the art of practical building. It goes against the logic of construction of the spaces and volumes which serve for the habitation and the everyday needs of human beings. That is to say the functional element has not been fully considered and technology was used only to enhance artistic inspirations and motivations.

One must conclude that it was the close contact of Czech architects with painters and sculptors in the *Skupina*, and similarly in Duchamp-Villon's case with the Paris *Groupe de Puteaux*, which brought the main pressure of influence. These

110

cooperations and discussions must have inevitably led to the interaction of architectural and artistic inspirations.

Like the paintings and sculptures the buildings were totally extrovert, trying to impress their image into the spectator's inner self. The emphasis was on his first impression and his subsequent emotional reaction. It was a reaction, a captivation required of one after seeing a highly interesting object. The aim was not just to build a dwelling but to create a work of art.

The Cubist approach to architecture, with its effort to achieve a synthesis of intellect and instinct, and its theoretical backing, extreme as it appears to be, is still valuable to us as a source of inspiration,[4] which brings forward the intellectual and artistic side of our creativity which is nowadays pushed so much out of the way.

89　Memorial to the March Victims,
　　Weimar, plan, W. Gropius, 1920-1

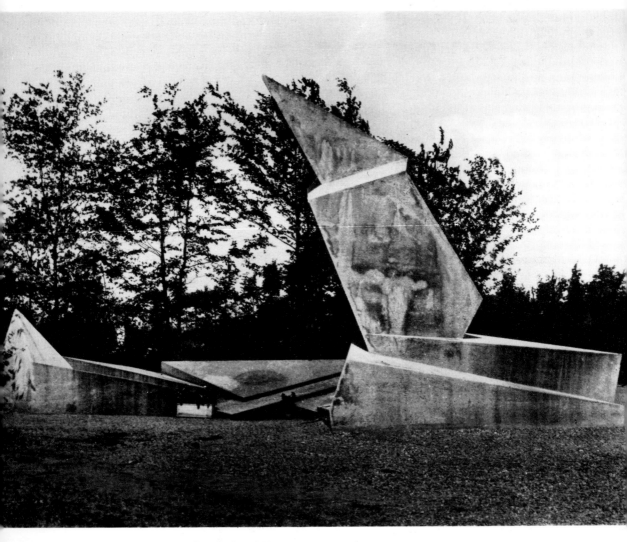

90 Memorial to the March Victims,
 Weimar, W. Gropius, 1920-1

112

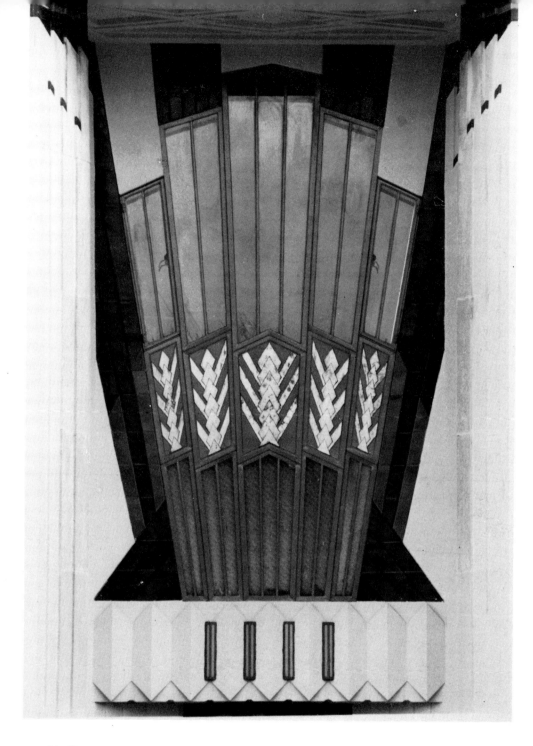

91 Hoover Factory, Perivale, facade detail
 Wallis, Gilbert & Partners, 1932

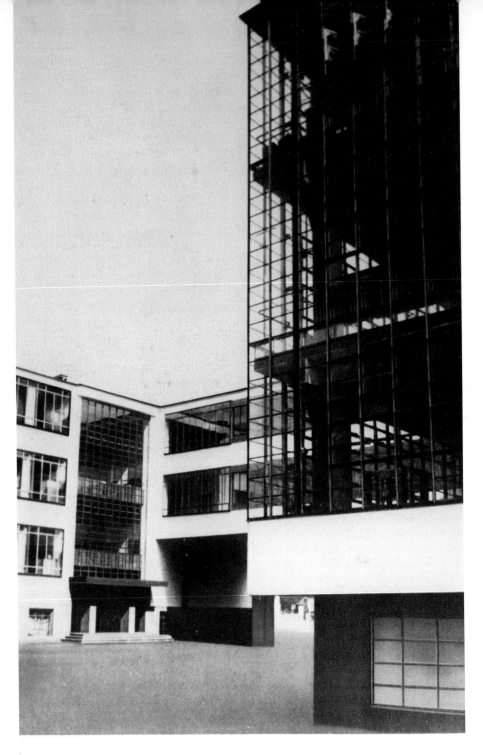

92 Bauhaus, Dessau, W. Gropius, 1926

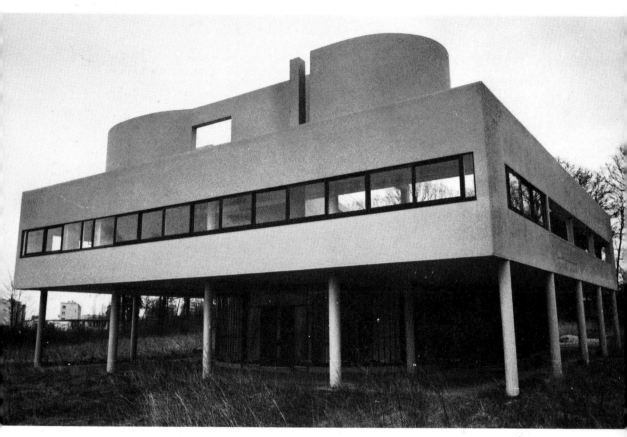

93 Villa Savoye, Poissy, Le Corbusier &
 P. Jeanneret, 1928-30

Chronology 1900-1920

	Bohemia	France	Elsewhere
1900	J. Kotěra, Peterka Building, Prague	H. Guimard, Metro entrances, Paris	Art Nouveau movement in its peak
1901	J. Fanta, Main Station, Prague,—1909	T. Garnier, *Cité Industrielle,*—1904 F. Jourdain, Samaritaine Store, Paris	
1902	O. Polívka, Novák Department Store, Prague, —1903		
1903		A. Perret, Apartment Block, Rue Franklin, Paris	T. Lipps publishes *Asthetik*. H. P. Berlage, Bourse, Amsterdam. *Wiener Werkstätte* founded
1904		J. Guadet publishes last volume of *Éléments et Théories de l'Architecture*	B. Parker, R. Unwin, Garden City, Letchworth
1905	J. Kotěra, National House, Prostějov, —1907	*Les Fauves* introduced in the Salon d'Automne, Paris	R. Maillart, Bridges, Switzerland. O. Wagner, Post Office, Vienna. J. Hoffmann, Palais Stoclet, Brussels. A. Gaudí, Casa Milà, Barcelona, —1910
1906	A. Balšánek, O. Polívka, Municipal House, Prague, —1911	A. Perret, Garage Ponthieu, Paris	H. van de Velde, School of Applied Arts, Weimar F. L. Wright, Unity Church, Oak Park
1907		P. Picasso paints *Les Demoiselles d'Avignon*	*Deutscher Werkbund* founded

1908	J. Kotěra, Own Villa and Laichter House, Prague	G. Braque exhibits *Houses at L'Estaque.* L. Vauxcelles writes about 'cubes'.	W. Worringer publishes *Abstraktion und Einfühlung* A. Loos publishes *Ornament und Verbrechen*
1909	J. Gočár, Wenke Department Store, Jaroměř. J. Gočár, Gregr Apartment, Prague P. Janák, Hlávka Bridge, Prague O. Novotný, Štenc House, Prague	Picasso and Braque: Analytical Cubism	P. Brehens, AEG Factory, Berlin F. T. Marinetti publishes the Futuristic Manifesto, *Le Figaro* F. L. Wright, Robie House, Chicago
1910	P. Janák, Articles in *Styl II*	G. Apollinaire mentions 'Cubism' for the first time (*Poesie*) A. Perret, H. van de Velde, Théâtre des Champs-Elysées, Paris	A. Loos, Steiner House, Vienna
1911	J. Gočár, Sanatorium, Bohdaneč, 'Black Virgin Mary' House, Prague. P. Janák, Houses, Pelhřimov. *Skupina výtvarných umělců* and *Umělecký měsíčník* founded	The first large Cubist exhibitions: Salon des Indépendants (Room 41), Salon d'Automne, Paris *Groupe de Puteaux* meetings begin. M. Duchamp, *The Coffee Mill*	W. Gropius, Fagus Factory, Alfeld
1912	*Pražské umělecké dílny* founded. Cubist furniture. Exhibition of *Skupina* and works by Picasso, Derain, Friesz; Prague V. Hofman, Cemetery entrance ; V. Hofman, P. Janák, articles in *Umělecký měsíčník*	R. Duchamp-Villon exhibits *Maison Cubiste* at Salon d'Automne, Paris *Section d'Or* exhibition, Paris. A. Gleizes, J. Metzinger, publish *Du Cubisme*	H. Poelzig, Reservoir, Posen (Expressionism)

117

1913	J. Chochol, Villa and Apartment Blocks, Prague P. Janák, O. Gutfreund, Žižka Monument design	Synthetic Cubism G. Apollinaire publishes *Les Peintres cubistes*	
1914	R. Duchamp-Villon exhibits in Prague Two last numbers of *Umělecký měsíčník*	R. Duchamp-Villon, *Project d'Architecture*	Werkbund exhibition, Cologne. A. Sant 'Elia publishes *Manifesto dell' Architettura Futurista* B. Taut, Glass Pavillion, Cologne
1914-1918	World War I		
1917			de Stijl founded, Leiden
1918	J. Kroha, 'Montmartre' club, Prague	A. Ozenfant, C. E. Jeanneret (Le Corbusier) publish *Aprés le Cubisme* (Purism)	
1919	J. Kroha, Studies of churches and monuments	Le Corbusier and Ozenfant found *L'Espirit Nouveau*, Paris	W. Gropius founds Bauhaus, Weimar
1920	J. Kroha, Design for Crematorium, Pardubice	Le Corbusier, *Maison Citrohan* —1922	W. Gropius, Memorial to the March Victims, Weimar M. Taut, Design for Community Centre Grünewald, Berlin Wissinger Tomb, Stahnsdorf E. Mendelsohn, The Einstein Tower, Potsdam N. Gabo, A. Pevsner publish the *Realistic Manifesto* (Constructivism)

118

References

Introduction
1 Janák, P. 'About Furniture and Other Objects', *Umělecký měsíčník*, vol 2, (1912-13), 21

Chapter 2
1 Lipps, T. 'Estetika prostorová', *Styl*, vol 5, (1913), 98-117
2 Chochol, J. 'The Function of Architectonic Element', *Styl*, vol 5, (1913), 93-9
3 Hofman, V. 'The New Principle in Architecture', *Styl*, vol 5, (1913) 13

Chapter 3
1 Duchamp-Villon, R. *Manuscript Notes*, Part III (undated, probably 1911), in the artist's estate, printed in *Raymond Duchamp-Villon* by G. H. Hamilton & W. C. Agee (Walker & Co, New York, 1967), 111
2 Duchamp-Villon, R. 'Résponse à une enquête au suject de La Danse de Carpeaux à l'Opéra', *Gil Blas*, (17 Sept 1912)

Chapter 4
1 Burgess, G. 'The Wild Men of Paris', *The Architectural Record*, (May, 1910), 405
2 Minkowski, H. *Raum und Zeit*, an address delivered at the 80th Assembly of German Natural Scientists and Physicians at Cologne, 21 September 1908, reprinted in *The Principle of Relativity* by H. A. Lorentz and others (Methuen & Co, London, 1923), 75
3 Giedion, S. *Space, Time and Architecture* (Harvard University Press, Cambridge Massachusetts, 1967), 436

Chapter 5
1 Janák, P. 'From Modern Architecture Towards Architecture', *Styl*, vol II, (1910), 105-9

Chapter 6
1 Janák, P. 'The Prism and the Pyramid', *Umělecký měsíčník*, vol 2, (1911-12), 168
 'The Facade Revival', *Umělecký měsíčník*, vol 2, (1912-13), 85
 'About Furniture and Other Objects', *Umělecký měsíčník*, vol 2, (1912-13), 21
2 Janák, P. 'About Furniture and Other Objects', *Umělecký měsíčník*, vol 2, (1912-13), 21
3 Janák, P. 'About Furniture and Other Objects', *Umělecký měsíčník*, vol 2, (1912-13), 21
4 Hofman, V. 'A Contribution to the Characteristics of Modern Architecture'. *Umělecký měsíčník*, vol 1, (1911-12), 230

5 Hofman, V. 'The Spirit of Modern Creativity in Architecture', *Umělecký měsíčník*, vol 1, (1911-12), 129-135
6 Hofman, V. 'The Individualizing Form in Architecture', *Volné Směry*, vol 18, (1914), 241
7 Chochol, J. 'The Function of Architectonic Element', *Styl*, vol V, (1913), 93

Chapter 7
1 Pach, W. *A Sculptor's Architecture*, (Association of American Painters and Sculptors, New York, 1913)
2 Hamilton, G. H. & Agee, W. C. *Raymond Duchamp-Villon*, (Walker & Co, New York, 1967), 65-9
 Pradel, M. N. 'La maison cubiste en 1912', *Art de France*, vol 1, (1961). 177-86
3 Duchamp-Villon, R. 'L'architecture et le fer', *Poème et Drame*, vol VII, (1914),28
4 Pach, W. *R. Duchamp-Villon, Sculpture 1876-1918*, (J. Quinn et ses Amis, Paris, 1924), 14
5 Duchamp-Villon, R. Letter to W. Pach, (16 Jan, 1913), Ibid, 18
6 Duchamp-Villon, R. Letter to W. Pach, (17 March, 1914), Ibid, 19

Chapter 9
1 Štěch, V. V. *Tschechische Bestrebungen um ein modernes Interieur, J. Gočár, P. Janák, F. Kysela. Werkbund-Ausstellung in Köln 1914*, (Praha 1915), written for the Deutscher Werkbund Exhibition, Cologne, 1914
2 Teige, K. *Vývojové proměny v umění*, (Nakladatelství československých výtvarných umělců, Praha, 1966), 191
3 Štěch, V. V. *Tschechische Bestrebungen um ein modernes Interieur*, (Praha 1915), written for the Deutscher Werkbund exhibition, Cologne, 1914
4 Apollinaire, G. 'Le Cubisme', *L'Intermédiaire des chercheurs et des curieux*, 10 October 1912, reprinted in *Apollinaire on Art: Essays and Reviews 1902-18* by G. Apollinaire, edited by Leroy C. Breunig (Thames & Hudson, London, 1962), 256-8
5 Janák, P. 'On Usefulness of Applied Arts Industry', *Umělecký měsíčník*, vol 1, (1911-12), 148
6 Štěch, V. V. *Tschechische Bestrebungen um ein modernes Interieur*, (Praha 1915), written for the Deutscher Werkbund exhibition, Cologne, 1914

Chapter 12
1 Jessen, P. *Jahrbuch des Deutschen Werkbundes*, (München 1915), 10
2 Giedion, S. *Space, Time and Architecture* (Harvard University Press, Cambridge, Massachusetts, 1967), 493

3 Giedion, S. *Space, Time and Architecture* (Harvard University Press, Cambridge, Massachusetts, 1967), 529

4 Stamp, G. 'How Hillingdon Happened', *The Architectural Review*, 984, February (1979), 85-89, for an example

Bibliography

Books

Apollinaire G., *Les Peintres cubistes: Méditations esthétiques*, Figuière, Paris 1913, Wittenborn, Schultz, New York 1949

Apollinaire, G., *Apollinaire on Art: Essays and Reviews 1902-1918*, Thames and Hudson, London 1972

Banham, R., *Theory and Design in the First Machine Age*, Architectural Press, London 1970

Benešová, M., *Josef Gočár*, NČVU Praha 1958

Benešová, M., *Pavel Janák*, NČVU Praha 1959

Císařovský, *Jiří Kroha a meziválečná avantgarda*, NČVU Praha 1967

Cooper, D., *The Cubist Epoch*, Phaidon, London 1970

Dostál, O., and others, *Modern Architecture in Czechoslovakia*, NČVU Praha 1967

Fry, E. F., *Cubism*, Thames and Hudson, London 1966

Giedion, S., *Space, Time and Architecture*, Harvard University Press, Cambridge 1967

Gleizes, A., and Metzinger, J., *Du Cubisme*, Figuière, Paris 1912, T. F. Unwin, London 1913

Golding, J., *Cubism: a History and Analysis 1907-1914*, Wittenborn, Schultz, New York 1959

Habasque, G., *Cubism*, Skira, Geneva 1959

Hamilton, G. H., and Agee, W. C., *Raymond Duchamp-Villon*, Walker & Co., New York 1967

Hatje, G., and others, *Encyclopaedia of Modern Architecture*, Thames and Hudson, London 1963

Kahnweiler, D. H., *Der Weg zum Kubismus*, Delphin, München 1920, Wittenborn, Schultz, New York 1949

Kotalík, J. *Václav Špála*, Odeon Praha 1972

Lamarová, M., and Herbenová, O., *Český kubistický interier*, UPM July-September 1976, Praha, exhibition catalogue

Mackertich, T. & P., *Facade*, Mathews Miller Dunbar, London 1976

Martin. J. L., and others, *Circle, International Survey of Constructive Art*, Faber and Faber, London 1971

Mullins, E., *Braque*, Thames and Hudson, London 1968

Novotný, O., *Jiří Kotěra a jeho doba*, SNKLHU Praha 1958

Pach, W., *A Sculptor's Architecture*, Association of American Painters and Sculptors New York 1913

Pach, W., *Raymond Duchamp-Villon, Sculpture 1876-1918*, John Quinn et ses Amis, Paris 1924

Pavel, J., *Dějiny našeho umění*, Česká grafická unie Praha 1939

Pehnt, W., *Expressionist Architecture*, Thames and Hudson, London 1973

Pevsner, N., *An Outline of European Architecture*, Penguin Books, London 1962

Pevsner, N., *Pioneers of Modern Design*, Museum of Modern Art, New York, 1949

Pevsner, N., and Richards, J. M., *The Anti-Rationalists*, Architectural Press London 1973

Richards, J. M., *An Introduction to Modern Architecture*, Penguin Books, London 1962

Rosenblum, R., *Cubism and Twentieth Century Art*, Abrahams, New York, 1961

Schwartz, P.W. *The Cubists*, Thames and Hudson, London 1971

Sharp, D., *A Visual History of Twentieth Century Architecture*, Heinemann, London 1972

Starý, O., and others, *Československá architektura od nejstarší doby po současnost*, NČVU Praha 1962

Štěch, V. V., *Tschechische Bestrebungen um ein modernes Interieur, J. Gočár, P. Janák, F. Kysela. Werkbund-Ausstellung in Köln 1914*, Praha 1915

Syrový, B., and others, *Architektura—Svědectví dob*, SNTL Praha 1974

Teige, K., *Modern Architecture in Czechoslovakia*, 1947

Teige, K., *Vývojové proměny v umění*, NČVU Praha 1966

Worringer, W., *Abstraktion und Einfühlung*, 6, unveränderte Auflage München 1908

Zevi, B., *Towards an Organic Architecture*, Faber and Faber, London 1950

Articles

Benešová, M., 'O kubismu v české architektuře', *Architektura ČSR* 3/1966, pp. 171-184

Benešová, M., 'Rondokubismus', *Architektura ČSR*, 5/1969, pp. 303-317

Burgess, G., 'The Wild Men of Paris', *The Architectural Record*, May 1910, pp. 401-414

Chochol, J., 'K funkci architektonického článku', *Styl* V/1913, pp. 93-99

Czagan, F., 'Kubistische Architektur in Böhmen', *Werk* 2/1969 pp. 75-79

Duchamp-Villon, R., 'L' architecture et le fer', *Poème et Drame* VII January-March 1914, pp. 22-28

Herbenová, O., 'Český nábytek v období kubismu', *Architektura ČSR* 3/1977, pp. 123-128

Hofman, V., 'Duch moderní doby v architektuře', *Umělecký měsíčník* 1/1911-1912, pp. 129-135

Hofman, V., 'Individualizující forma v architektuře', *Volné směry* 18/1914, pp. 241-253

Hofman, V., 'K podstatě architektury', *Volné směry* 17/1913, pp. 53-56

Hofman, V., 'Nový princip v architektuře', *Styl* V/1913, pp. 13-24

Hofman, V., 'Příspěvek k charakteru moderní architektury', *Umělecký měsíčník* 1/1911-1912, p. 230

Janák, P., 'Hranol a pyramida', *Umělecký měsíčník* 2/1912-1913, p. 168
Janák, P., 'Obnova průčelí', *Umělecký měsíčník* 2/1912-1913, p. 85
Janák, P., 'Od moderní architektury k architektuře', *Styl* II/1909-1910, pp. 105-109
Janák, P., 'O nábytku a jiném', *Umělecký měsíčník* 2/1912-1913, p. 21
Lipps, T., 'Estetika prostorová', *Styl* V/1913, pp. 98-117
Margolius, I., 'Cubism in Czech Architecture', *The Architectural Association Quarterly* 8/4, 1976, pp. 51-59
Pradel, M. N., 'La maison cubiste en 1912', *Art de France* I/1961. pp. 177-186
Vokoun, J., 'Czech Cubism', *The Architectural Review* 139/1966/829, pp. 229-233

Acknowledgements

The author would like to thank Pam Darlaston, Anne-Marie Ehrlich and his friends in Prague for helping to gather some of the photographs and illustrations, and NČVU Prague, Dilia Prague, SNTL Prague, *Architektura ČSR* Prague, Walker & Co New York, and Verlag G. Hatje, Stuttgart, for their permission to reproduce from their publications, and UPM (Museum of Decorative Arts) Prague for supplying photographs of objects in their collection. Every attempt to trace the origin and copyright of the plates has been made.

Photographs and illustrations are reproduced by permission of the following:

Dilia Prague from *Jan Kotěra a jeho doba* by O. Novotný, 1, 8;

NČVU Prague from *Československá architektura od nejstarší doby po současnost* by O. Starý and others, 2, 6, 21, 43;

Archív Knihtisk Prague, 3, 4, 7, 27, 29, 32, 33, 46, 55, 85, 87, 88;

Architektura ČSR Prague, 5, 17, 30, 71, 72;

The Museum of Modern Art New York, © SPADEM Paris, 1979, 9;

Kuntsmuseum Bern, © ADAGP Paris, 1979, 10;

Kuntsmuseum Basle, © ADAGP Paris, 1979, 11;

The Museum of Modern Art New York, © ADAGP Paris, 1979, 12;

The Museum of Modern Art New York from the catalogue of the Picasso Exhibition, 1939, © SPADEM Paris, 1979, 13;

National Gallery Prague, 14 (photo V. Fyman), 79, 80, 81;

Musée National d'Art Moderne, Pompidou Centre Paris, © ADAGP Paris, 1979, 15;

Arts Council of Great Britain, © ADAGP Paris, 1979, 16;

NČVU Prague from *Modern Architecture in Czechoslovakia* by O. Dostál and others, 18, 26, 35, 41, 42, 47, 52, 53;

NČVU Prague from *Josef Gočár* by M. Benešová, 19, 25, 28, 86;

NČVU Prague from *Pavel Janák* by M. Benešová, 20, 34, 37;

©ADAGP Paris, 1979, photo H. Josse, 22;

Mrs W. Pach and Walker & Co New York from *Raymond Duchamp-Villon* by G. H. Hamilton & W. C. Agee, © ADAGP Paris, 1979, 23, 24;

SNTL Prague from *Architektura—svědectví dob* by B. Syrový and others, 31, 48, 58, 63;

Verlag G. Hatje Stuttgart from *Expressionist Architecture* by W. Pehnt, 54, 90;

NČVU Prague from *Jiří Kroha a meziválečná avantgarda* by J. Císařovský, 56, 57, 60, 61;

UPM (Museum of Decorative Arts) Prague, 70, 74, 78, 82;

Bildarchiv Foto Marburg, 89;

I. Margolius, 91;

Inter Nationes Bonn, 92;

C. Jencks, 93.

Index